Jan Smuts 1870–1950

"Let us help one another along the road of life.
Let us wipe the slate clean and extend the hand of friendship …"

Jan Smuts
1870–1950

A PHOTOBIOGRAPHY

Compiled by Anton Joubert
Foreword by Fransjohan Pretorius

Protea Book House *Pretoria* 2023

Dedicated to Charles

First edition, first impression in 2023, Protea Book House
PO Box 35110, Menlo Park, 0102
1067 Burnett Street, Hatfield, Pretoria
8 Minni Street, Clydesdale, Pretoria
info@proteaboekhuis.co.za
www.proteaboekhuis.com

EDITOR: Danél Hanekom
PROOFREADER: Carmen Hansen-Kruger
LAYOUT AND DESIGN: Hanli Deysel
COVER: Smuts as MP in Pretoria West, April 1924
(Archives of the SA Parliament)
SET IN: 11.5 on 15 pt Palatino
PRINTED AND BOUND BY TOPPAN LEEFUNG PRINTING LTD., CHINA

Original text © 2023 Anton Joubert
Published edition © 2023 Protea Book House

ISBN: 978-1-4853-1384-7

Contents

Foreword

SOME EXCITING PUBLICATIONS about General Jan Smuts have been published recently. Amongst them were the impressive *Jan Smuts: Son of the Veld, Pilgrim of the World,* with Kobus du Pisani as general editor (2019), and the two popular works by Richard Steyn, entitled *Jan Smuts: Unafraid of Greatness* (2015) and *Churchill's Confidant: Jan Smuts, Enemy and Lifelong Friend* (2018).

These new works on Smuts indicate that the pace of historical writing and the interest shown by the reading public have taken on an almost cyclical pattern. That which was important long ago can gain importance once again as the pieces of the historical kaleidoscope shift to form new patterns, and new questions are raised about the past. And it is only right that now, well into our new political dispensation born in 1994, we revisit our past, because Smuts played a crucial role in these developments. He was the one who, early in the twentieth century, said that the race problem should be resolved by the views of future generations.

For this reason, I welcome this photobiography of Smuts with enthusiasm. Compiled by Anton Joubert, the endeavour began ten years ago when Anton was asked by Prof. Christof Heyns to gather every Smuts photograph possible to add to the collection held at the University of Pretoria. Subsequently, the search took Anton to several archival collections in South Africa.

On my bookshelf are two photobiographies of Jan Smuts. The first appeared in October 1950, a month after his death, and is entitled *Salute to a Great South African: Jan Christiaan Smuts May 24, 1870–September 11, 1950.* The second is *Jan Smuts: An Illustrated Biography* (1994) compiled by Trewhella Cameron. These two works are superb precursors to Anton Joubert's new contribution. With some luck the earlier publications can still be found on the internet, and the selection of images possibly overlaps, but Anton's photobiography gives the modern reader a fresh perspective on Smuts. The photographs taken during World War II are especially welcome and show his wide influence in the Allied war effort. Extensive captions along with excellent short historical overviews in each of the five chapters provide valuable information and food for thought. This is indeed a worthy contribution to the literature on an eminent South African.

Fransjohan Pretorius
PROFESSOR EMERITUS
DEPT. HISTORICAL AND HERITAGE STUDIES
UNIVERSITY OF PRETORIA
OCTOBER 2022

From "a young son of the veld" to cabinet minister
1870–1913

"Having no human companion, I felt a spirit of comradeship for the objects of nature around me. In my childish way I communed with these as with my own soul; they became the sharers of my confidence."

JAN CHRISTIAAN SMUTS was born on 24 May 1870 in a house named Bovenplaats on the family farm Ongegund (Begrudged) near Riebeek West, a village in the prosperous wheat- and vine-growing region of the Swartland in the Western Cape. His father, Jacobus Abraham Smuts, a sixth-generation descendant of the first Smuts who came to the Cape from the Netherlands, was a farmer and member of the Cape Colony's legislature. His mother, Cato de Vries, was a seventh-generation descendant of Jacob Cloete, who had come to the Cape with Jan van Riebeeck in 1652.

Little Jan was a frail and sickly child, who grew up tending his father's sheep and goats — while marvelling at the beauty of the flora, fauna and surrounding mountainsides — before being sent to school for the first time at the age of 12. Catching up rapidly and overtaking his classmates, the young Smuts was described by his teacher as the most brilliant and hard-working pupil he had ever taught. The boy soon mastered English, which he always spoke with a distinctive Malmesbury "bry", and read voraciously in both Dutch and his new language.

Influenced by his devout parents, who wished him to become a minister in the Dutch Reformed Church, the young Smuts was deeply religious, and taught the younger pupils (including another future prime minister, D.F. Malan) at the Sunday School in Riebeek West, until he was sent, aged 16, to Victoria College in Stellenbosch to matriculate. In 1888, he passed the matriculation exam with distinction, being one of the top three students in the Cape Colony. In ninth place was a close friend, Sybella "Isie" Krige, from an old Stellenbosch family, the studious young girl he would eventually marry.

Smuts's outstanding academic achievements at Stellenbosch won him the prized Ebden scholarship to Christ's College, Cambridge University, where he studied law and proved to be one of the most brilliant students in the College's long and distinguished history. He was admitted to the Middle Temple after passing the required examination with distinction. However, he yearned for home and returned to Cape Town in 1895 and opened a practice at the Cape Bar.

A supporter of the Afrikaner Bond and Cape premier Cecil J. Rhodes's policy of fostering English-Dutch unity, Smuts was so disillusioned by the Rhodes-inspired Jameson Raid that he abandoned his colonial citizenship and moved to the Transvaal where he joined the Johannesburg Bar. In April 1897, on a hurried return visit to the Cape, he and Isie were married in Stellenbosch.

President Paul Kruger responded to the arrival of a talented young lawyer in his midst by appointing Smuts as State Attorney of the Zuid-Afrikaansche Republiek (ZAR, South African Republic) at the tender age of 28. Smuts soon became one of the ZAR's most influential civil servants, accompanying Kruger to Bloemfontein in 1899 to meet Britain's high commissioner in South Africa, Sir Alfred Milner, who was intent on provoking war.

When the Anglo-Boer War broke out months later, the 29-year-old Smuts found himself alongside State Secretary F.W. Reitz at the helm of the Transvaal administration, while the generals went into the field. After the tide in the war turned against the Boers, and Pretoria fell to the British army under Lord Roberts in June 1900, Smuts joined Koos de la Rey's guerrilla force in the Western Transvaal, where he was soon appointed general. In June 1901, the republican governments decided to infiltrate the Cape Colony to relieve the pressure on the Boer republics, and Smuts was put in charge of the expedition. Early morning on 4 September, he and 220 raggedly dressed volunteers, among them Deneys Reitz, set off on a 3200-kilometre-long incursion through the Cape Colony which tied up some 35 000 British "khakis" in pursuit. From Okiep in the far northern Cape, Smuts was summoned back to the negotiations with the British at Melrose House, and the meeting of military leaders at Vereeniging that resulted in the peace treaty that brought an end to the war.

Disillusioned by the Boers' defeat, Smuts was brought back into Transvaal politics by his mentor Louis Botha, with whom he formed the *Het Volk* (The People) party to put pressure on the British government to grant self-government to its "new

colonies" in South Africa. When a new Liberal government came to power in Britain in 1906, Smuts was sent to London to assure Prime Minister Henry Campbell-Bannerman of the Boers' loyalty to the British Crown. He returned with a promise that self-rule would soon be forthcoming. Self-government was granted to the Transvaal in 1906, and Het Volk came to power in the first election: Louis Botha became prime minister and Smuts his minister of education and the interior.

In the meantime, pressure had begun to mount for the unification of Britain's four South African colonies. The British had long desired a federal system for the country, but at a National Convention of delegates from the colonial governments, which opened in Durban in 1908, Smuts succeeded in winning support for a unitary form of government. After a draft constitution had been approved by all four parliaments, Botha and Smuts led a delegation to Britain to witness the passage of the South Africa Act of 1909, which resulted in the birth of the Union of South Africa on 31 May 1910.

When Louis Botha's Governing Party won the first national election and Botha became prime minister, Smuts was given the three most important cabinet portfolios of minister of finance, mines and defence. In the latter role, he was responsible for establishing the Union Defence Force (UDF) in 1912. ✒

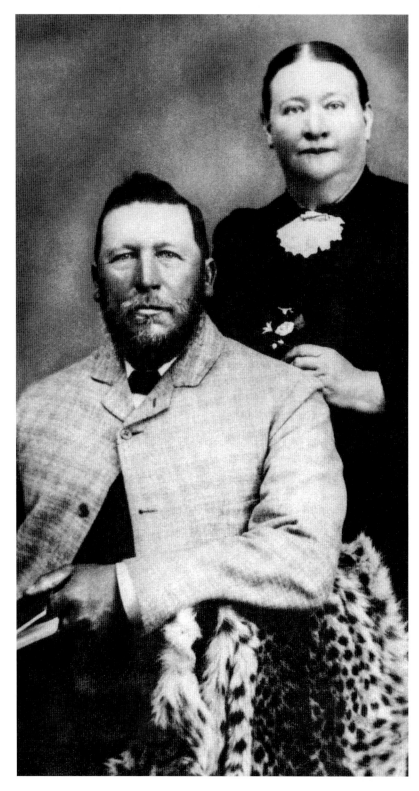

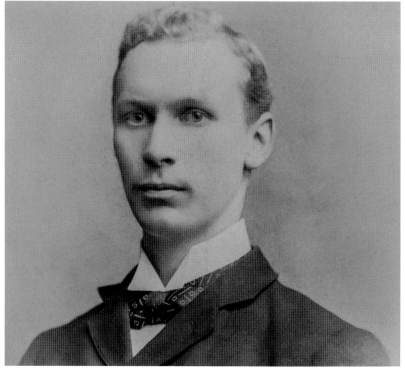

Smuts as a young man. He passed matric in 1888 with Greek (which he taught himself within a mere week) as one of his subjects.

A photograph taken in 1893 of Jacobus Abraham Smuts and Catherina Petronella (Cato) Smuts (née De Vries), the parents of Jan Smuts. He was named after his grandfather on his mother's side. His father was a wealthy farmer, the MP for Malmesbury in the Cape Colony parliament.

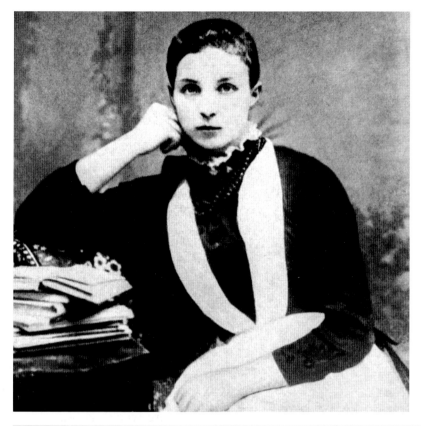

Sybella Margaretha (Isie) Krige (born 22 December 1870) met Smuts at Victoria College when he was 17 and she was 16 years old. He lived near her home, and they often walked together to class in Stellenbosch. Ten years later he asked her to marry him, and they were married on 30 April 1897 in the living room of the Krige home. Here Isie is pictured in 1888 as an 18-year-old girl.

The simple thatched homestead on Bovenplaats near Riebeek West in the then Malmesbury district where Smuts was born. His family had lived here until he was six years old, when his father bought the farm Klipfontein and the family moved there.

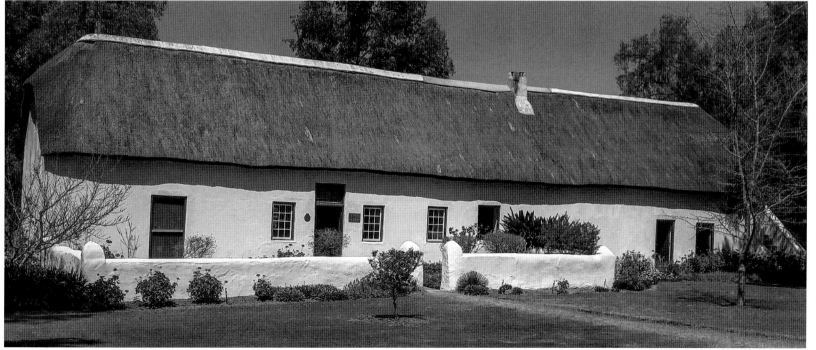

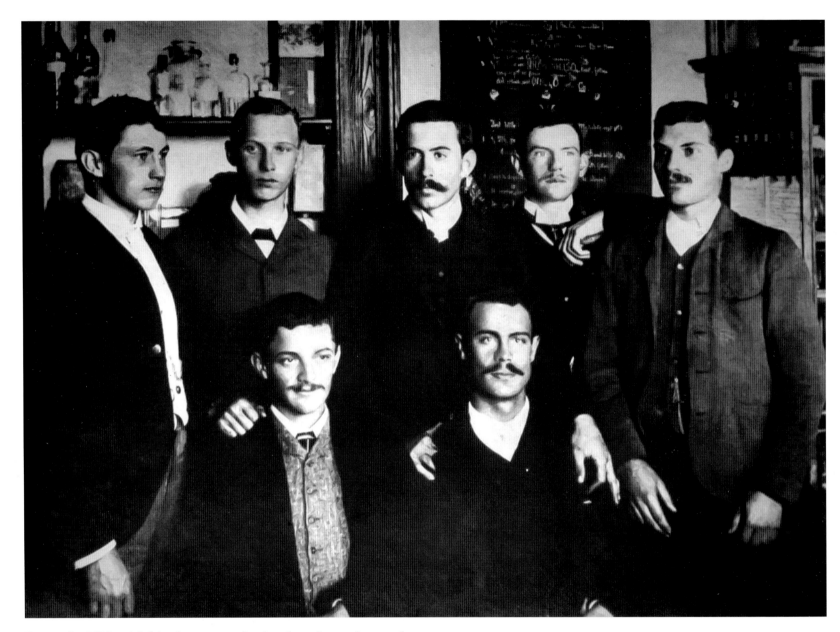

Smuts in 1890 with his classmates in the chemistry class at the Victoria College, where he received a double BA degree with science and literature as majors the following year. From left to right (back): H. Brincker, Smuts, J.N. de Vos, H. Stroebel and F.S. Malan (who served in the cabinet with Smuts from 1910 to 1924 and years later received an honorary doctorate with him from the University of Stellenbosch). From left to right (front): P.C. Luttig and M. Daneel.

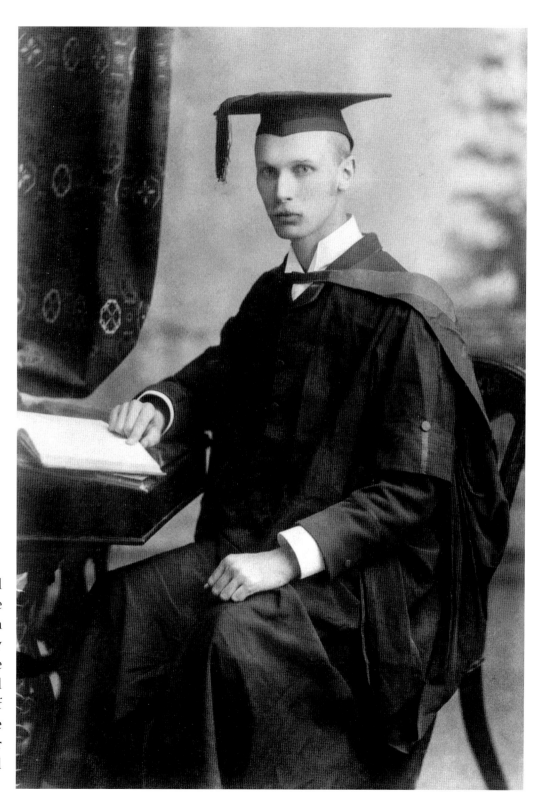

Smuts, the 21-year-old student, capped and gowned after receiving his BA degree in 1891. He was then awarded the Ebden scholarship of £100 per annum to read law at Cambridge where he secured a double first in the Law Tripos in 1894. Lord Todd proclaimed in 1970 that Smuts was one of the top three students at Christ's College in the 500 years of its existence. The other two, in his view, were John Milton and Charles Darwin.

In 1895, Smuts returned to Cape Town where he practised as a junior advocate. His complex personality meant he had limited success with clients and he turned instead towards journalism to earn extra income. The following year Smuts relocated to Johannesburg where he caught the eye of President Paul Kruger when he supported the president in a statement made during a legal dispute. At the young age of 28, he was appointed by Kruger as state attorney of the ZAR in June 1898. This photo is dated 1903.

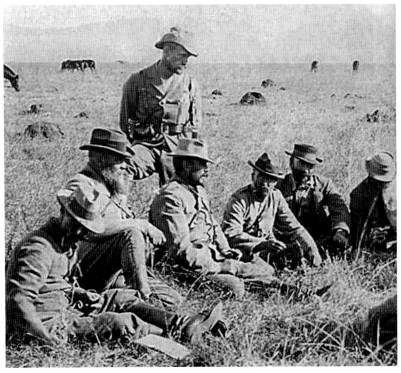

In the initial phases of the Anglo-Boer War all the ZAR administrative tasks fell on the shoulders of Smuts. He was able to remove all state documents just in time before Pretoria fell on 4 June 1900. The British believed that the fall of Pretoria symbolised their victory, but they were wrong! Here Gen. Louis Botha and Smuts are photographed in conversation east of Pretoria, determined to continue fighting. The British approached Botha's wife, Annie, and Isie Smuts in attempts to end the war. Both were brought to the front to convince their husbands to stop fighting. However, Botha and Smuts decided to continue their guerrilla tactics and the war dragged on for two more years.

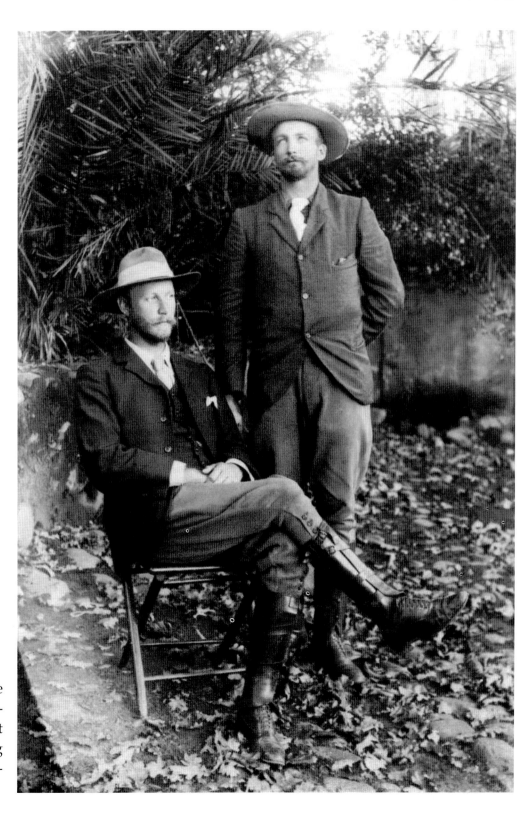

Smuts and his brother-in-law "Tottie" Krige who accompanied him on the guerrilla campaign into the Cape Colony from 1 August 1901. Tottie played a major role in keeping Isie and the Krige family informed of developments on the front.

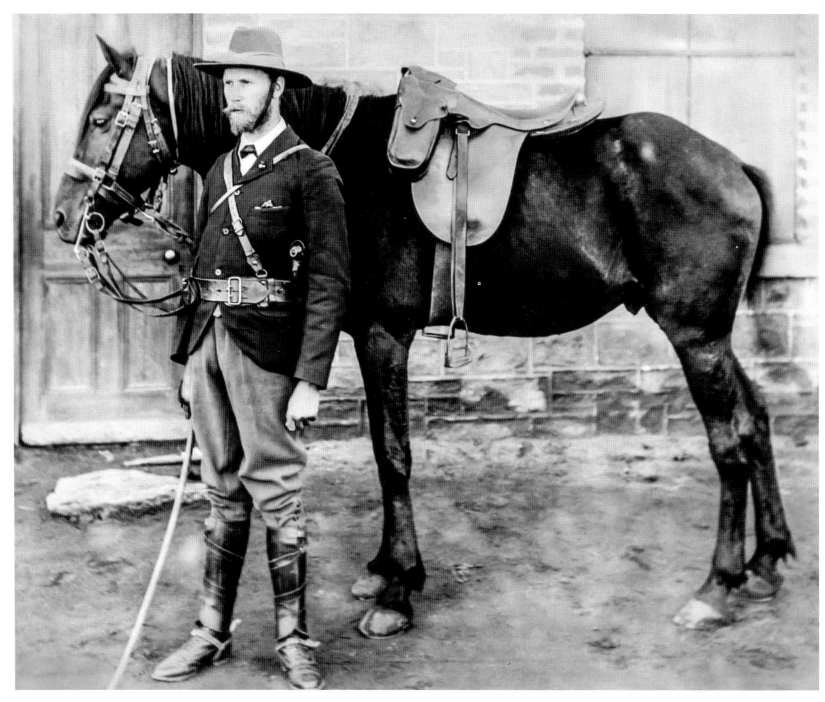

Smuts and his horse, Charlie. During the invasion of the Cape Colony, the commandos were in Namaqualand when the stallion was shot. Fortunately, Smuts was not hurt (1902).

Smuts (seated) with generals Jaap van Deventer (left) and Manie Maritz in Namaqualand during the siege of Okiep in April 1902. As assistant commandant general, Smuts was closely involved in the war at strategic, operational and tactical level. He participated in at least 30 battles. During the epic guerrilla campaign from the eastern to western Cape Colony towards the end of the war, Smuts was the commander-in-chief responsible for operations behind British lines. On 26 April 1902, accompanied by the British, he departed for Port Nolloth from Klipfontein in the vicinity of Okiep. From Port Nolloth he sailed to Cape Town and travelled by train to Vereeniging to attend the peace negotiations.

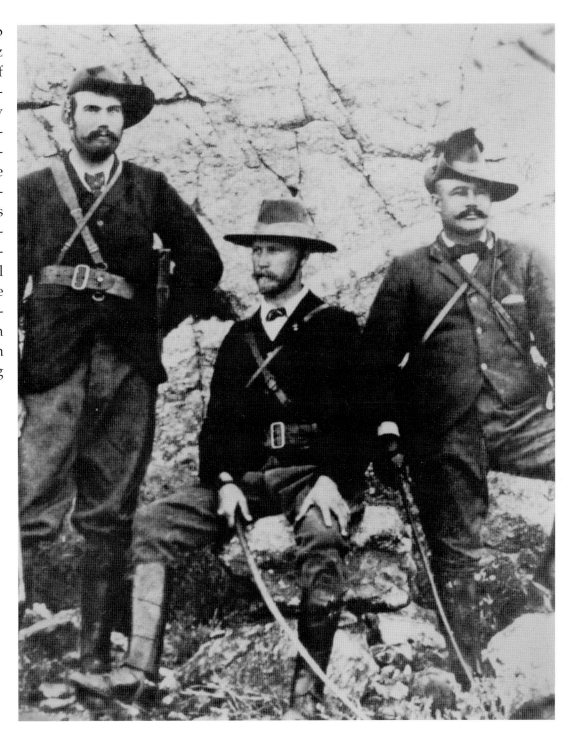

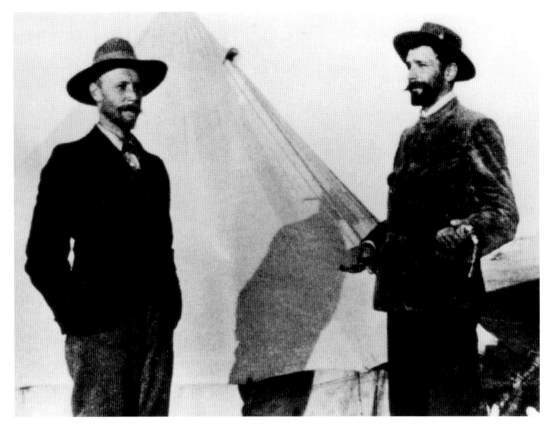

Smuts with Gen. Christiaan Beyers in front of their tent during the peace conference at Vereeniging in May 1902. Beyers was the chairperson at the conference while Smuts was the legal advisor of the ZAR and thus had no voting rights. It was here that Lord Kitchener mentioned to Smuts that a future British Liberal government would be sympathetic towards the Boers.

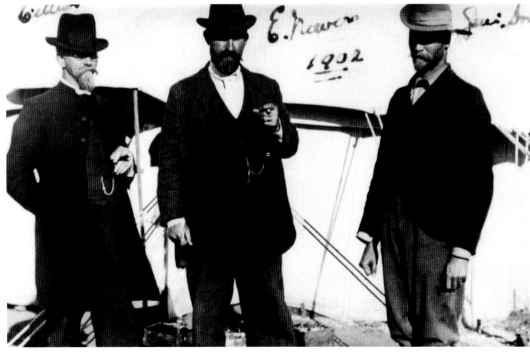

With Rev. Cilliers and E. Navera at the peace negotiations.

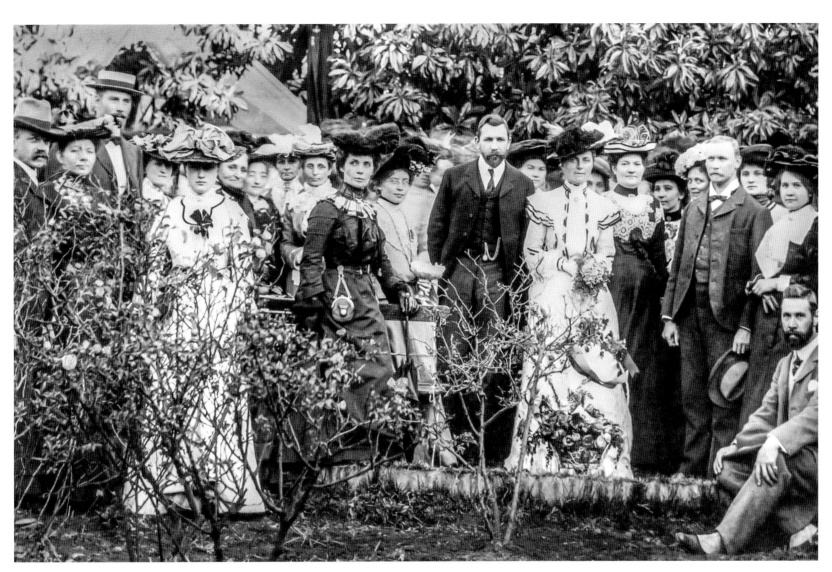

This social gathering in Pretoria in 1903 took the form of a garden party. In the middle is Gen. C.F. Beyers and to his left is Emily Hobhouse, while Smuts stands to her left. Hobhouse was a pro-Afrikaner activist during the Anglo-Boer War. Through her efforts, the scandalous British concentration camps and the atrocities committed there were brought to public notice and contributed to the downfall of the Tory Party in January 1906. This paved the way for the 35-year-old Smuts to negotiate full self-governing status for the British-ruled colonies with the new Liberal Party government in Britain.

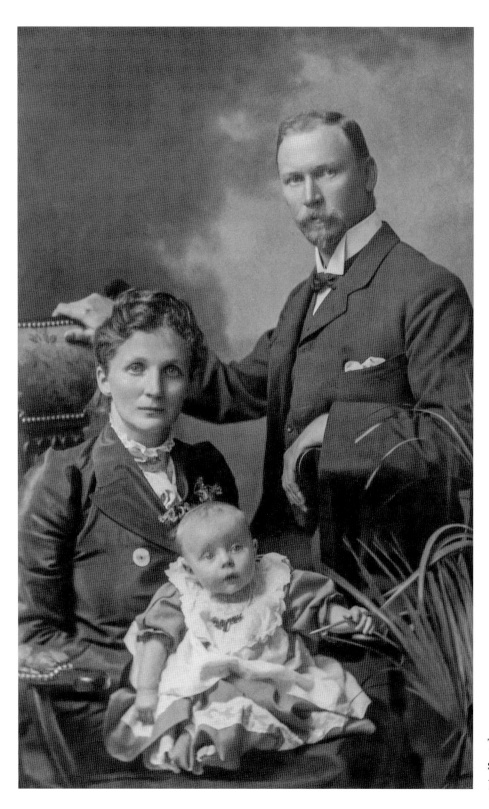

The Smuts parents with their eldest daughter, Susannah Johanna (Santa), who was born on 14 August 1903. She was named after her Krige grandmother.

Smuts and Botha in Pretoria on their way to work. Here Isie, holding their young son Japie, sees them off.

The delegates to the National Convention held in Durban on 12 October 1908, where a draft constitution of the Union of South Africa was discussed. Top right is Smuts (in the light suit), who was the Transvaal state secretary at the time. This was one of the highlights of Smuts's life, so much so that an enlargement of this photo still hangs above his writing desk in the study at Doornkloof.

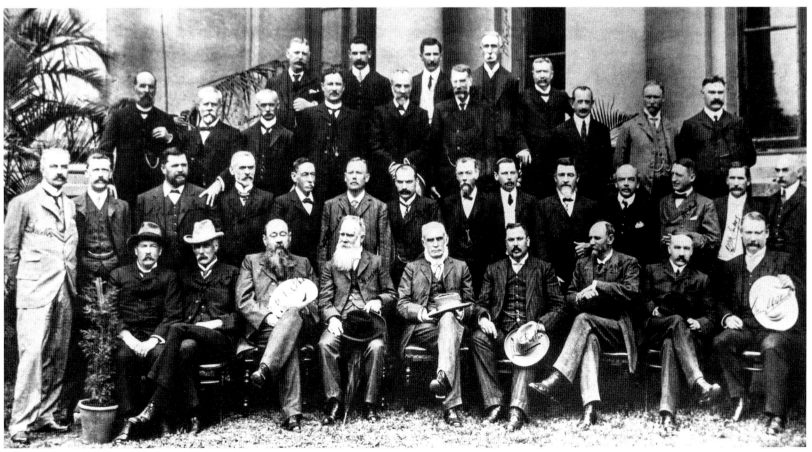

In 1907, Smuts was minister of the interior and education in the Transvaal government. Throughout his life, Smuts showed an abiding interest in various forms of education. He was closely involved, among other things, in the establishment of the Transvaal University College (Tuks) in 1908.

OPPOSITE Louis Botha, John X. Merriman (sitting) and Smuts in 1910. These three were the leading role players responsible for the unification of South Africa. Botha became the first prime minister of the Union. Smuts, his second in command, was appointed as minister of the interior, defence and mining. Merriman (elderly by this time), the respectable figure of South African politics since 1869, secretly expected to be named as the first prime minister and when disappointed, refused to serve in Botha's cabinet. He served as parliamentary member for Victoria West and then for Stellenbosch until 1924. He passed away on 2 August 1926, almost 38 years after he first met Smuts as a matriculant at Stellenbosch.

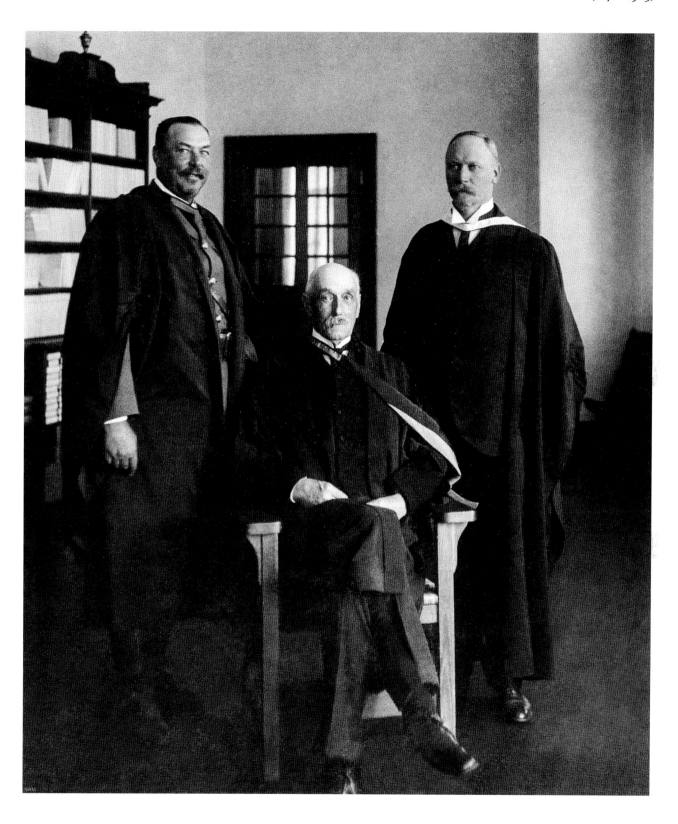

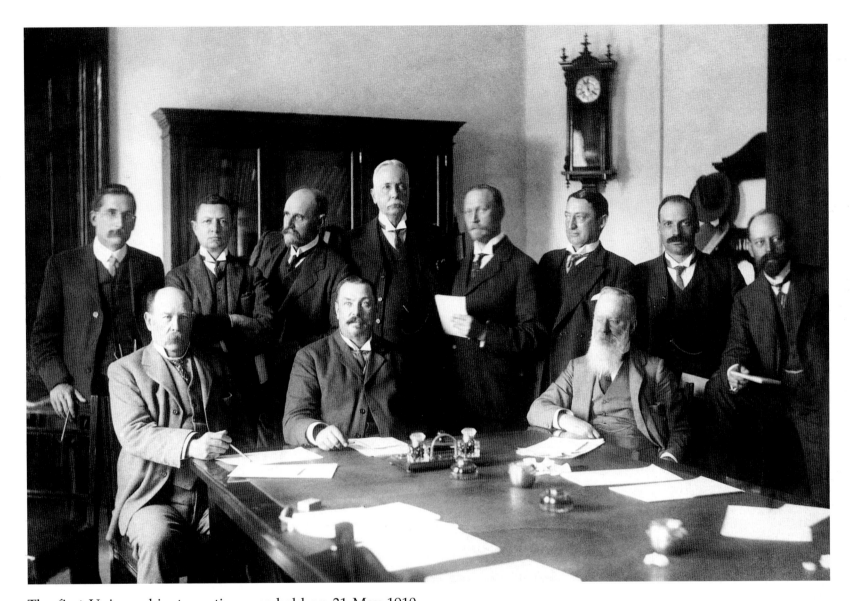

The first Union cabinet meeting was held on 31 May 1910. In front (from left to right) are: J.W. Sauer (railways and harbours), Louis Botha (prime minister, foreign affairs and agriculture) and Abraham Fischer (lands and water affairs). At the back (from left to right): J.B.M. Hertzog (justice), Henry Burton (native affairs), F.R. Moor (commerce and industry), C. O'Grady Gubbins (minister without portfolio), J.C. Smuts (interior, defence, mining and industry), H.C. Hull (finance), F.S. Malan (education) and David de Villiers Graaff (posts and telegraphs, and public services).

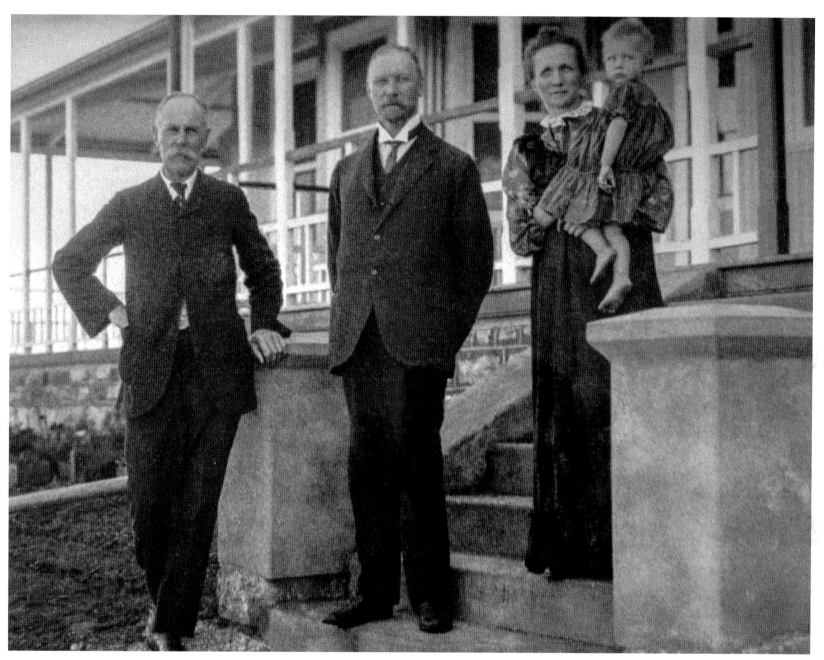

Smuts and Isie (with Santa on her hip) in front of their newly built home on the farm Doornkloof in Irene in 1909. With them is Lord Methuen on an overnight stay. They are photographed on the steps of the club building (formerly a British officers' mess at Middelburg, Transvaal, during the war) which Smuts bought and relocated piece by piece to his farm in 1909. Smuts resided on this farm until his death. Methuen was the British commander at the Battle of Magersfontein where the British forces were defeated. He was the general officer commanding-in-chief for South Africa from 1908. Smuts consulted with Methuen while drafting the Union Defence Force Act of 1912.

Soldier and peacemaker
1914–1919

"I have fought this Peace from the inside with all my power, and have no doubt been able in the end to secure some small openings of hope for the future."

WHEN WORLD WAR I BROKE OUT in 1914, Britain lost no time in asking the fledgling Union Defence Force (UDF) to go into action in neighbouring German South West Africa (GSWA, now Namibia) by taking over the seaports along the Atlantic coastline and knocking out the powerful German radio transmitter in the capital, Windhoek. After a heated week-long debate, parliament endorsed the decision to invade GSWA despite the furious opposition of ex-Boer generals Hertzog, Beyers, Kemp and others, who saw an opportunity to lead a rebellion of anti-British Afrikaners against the Botha-led government and restore republican independence. It took several weeks before some 11 400 rebels were overcome by a much larger UDF unit comprising mainly of Afrikaners loyal to the elected government.

After a delayed start, UDF troops under the personal command of Prime Minister Louis Botha entered GSWA via the port of Lüderitzbucht in February 1915. After a well-led, six-month campaign during which Smuts took command for three weeks of one of three UDF columns marching northwards, Botha accepted the Germans' formal surrender – the first Allied success in the war. A proud Smuts declared the conquest of GSWA to be "the first achievement of a united South African nation".

Soon after returning to South Africa, Smuts accepted Britain's invitation to become commander-in-chief of the imperial forces in East Africa. He spent the next ten months chasing the German army under the elusive General Von Lettow-Vorbeck out of southern Kenya and modern-day Tanzania, before being recalled to South Africa and sent to London by Louis Botha to attend the Imperial War Conference of 1917.

Smuts arrived in Britain at a time when national morale was at a low ebb and food was in short supply because of U-boat attacks on Allied shipping. To his surprise, he found himself fêted by royalty and lionised as a former enemy now fighting – with great success – on the side of the Empire. At meetings of the Imperial War Conference, he made such a fine impression on British premier David Lloyd George that after the conference he was invited to stay on in London as the seventh member of the imperial war cabinet. He was given many delicate assignments – in France, Belgium, Ireland and on the Western Front.

When World War I ended unexpectedly in 1918, Smuts was handed the task of drafting Britain's brief for the forthcoming peace conference in Paris, besides devising a constitutional blueprint for the soon-to-be-established League of Nations (which US President Woodrow Wilson used in drafting his famous "14 Points" plan for world peace) and setting out South Africa's claim for a mandate over South West Africa.

Joined at the Paris peace conference at Versailles by Louis Botha, John Maynard Keynes, his former arch foe Alfred Milner, and others, Smuts argued forcefully (but unsuccessfully) against the imposition of over-harsh economic reparations on the defeated Germans. He felt so strongly that he signed the Treaty of Versailles only under duress, explaining his objections to it in a statement published in British newspapers.

With the world at his feet after the war, Smuts declined many tempting offers to stay in the UK and remain involved in international affairs. The deciding factors in his decision to return home to South Africa were his love for the country, his family, and the loyalty he felt to an ailing Louis Botha. ✒

OPPOSITE Generals Louis Botha and Koos de la Rey strolling through the Cape Town Gardens after the special parliamentary session about participation in World War I was adjourned. This was on 12 September 1914, just before De la Rey left for the North. He was tragically killed three days later by a ricochet bullet fired at a roadblock at Langlaagte on the West Rand after a misunderstanding. Botha and Smuts were deeply saddened by the death of their comrade-in-arms, friend and confidant. This photo still hangs in the entrance hall of the house at Doornkloof to this day. Smuts displayed it out of respect for his friend.

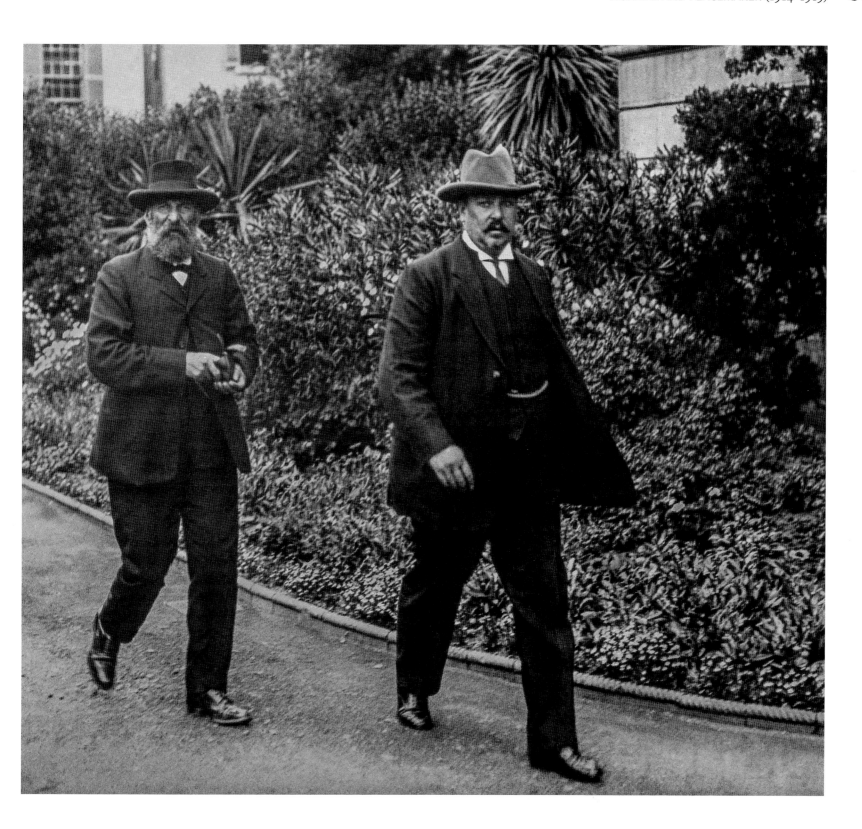

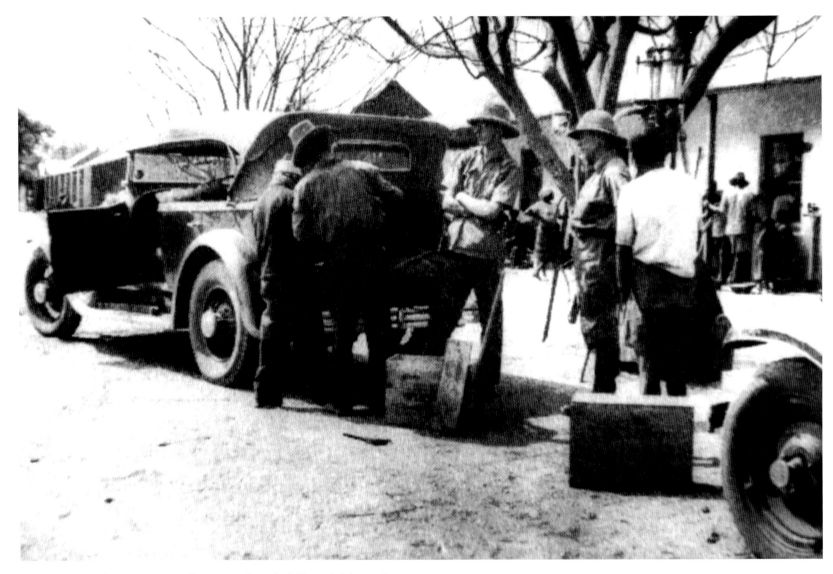

In 1915 on their way to German South West Africa where
Smuts was responsible for the rapid and successful occu-
pation of the southern part of that country.

Early in 1916 Smuts was honoured by the British government with his appointment as the commander-in-chief of the Allied forces in German East Africa (now Tanzania) and was promoted to lieutenant general during World War I.

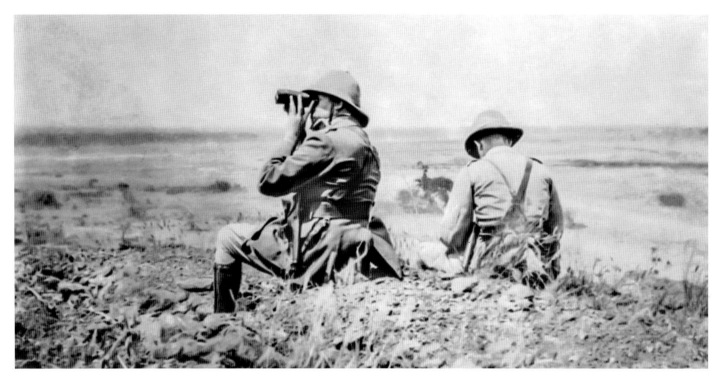

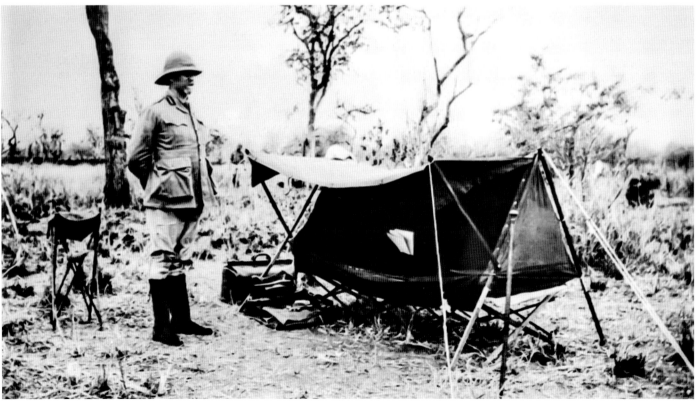

OPPOSITE, ABOVE Smuts and his trusted friend Brig. Gen. Jack Collyer are shown here on the war front, monitoring the conflict in the Pangani River valley in 1916. Since Union in 1910, Collyer was among the British officers who advised Smuts to draw up the Union Defence Force Act and establish the Union Defence Force (UDF). Later in 1939, during World War II, Collyer was appointed as Smuts's military secretary with the rank of major general.

OPPOSITE, BELOW Next to his camp bed (which also served as his office) at Tulo during the southern advance towards the German forces in German East Africa in 1916.

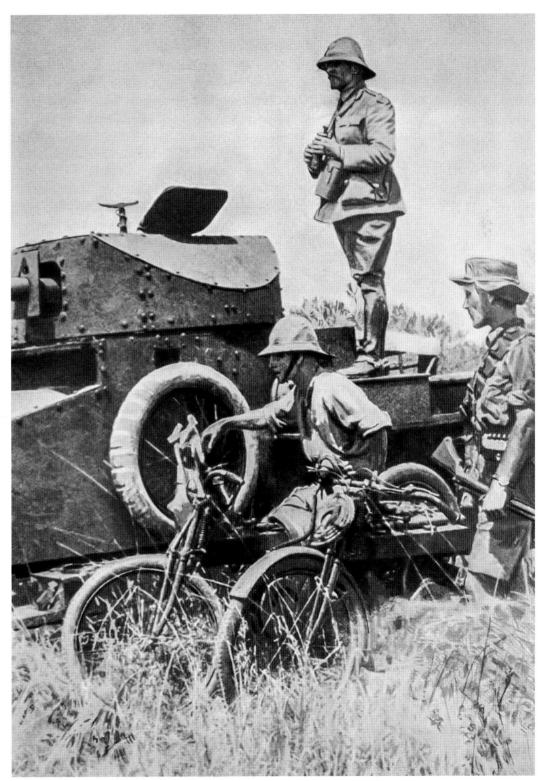

Inspecting the enemy lines from a Rolls-Royce armoured vehicle. True to his nature of attention to detail, Smuts did most of the reconnaissance on the frontline himself. His rapid and accurate decision making put the enemy under constant pressure.

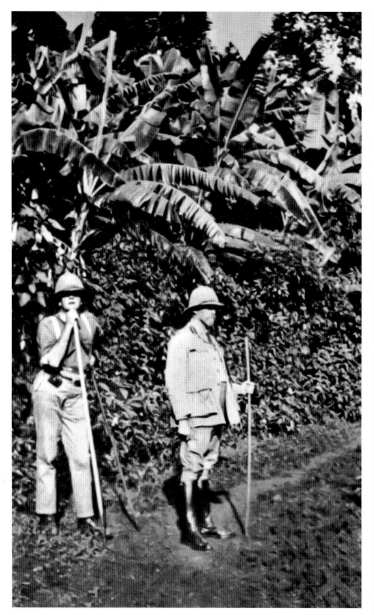

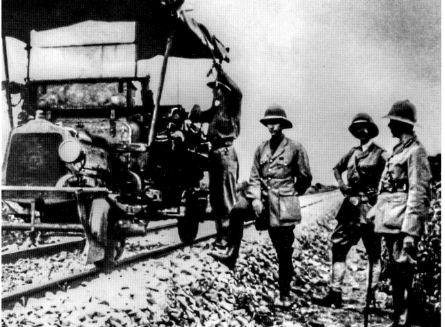

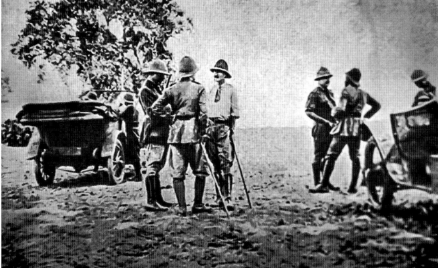

Here Smuts is photographed with Col. Deneys Reitz in a banana grove at Moschi. Deneys was the son of former President F.W. Reitz, and had a good working relationship with Smuts. Later he was a member of Smuts's cabinet and for a while he was the prime minister's personal representative in Britain. In 1943, Reitz was appointed South African high commissioner in London.

Prime Minister Botha visiting Smuts and the South African troops in German East Africa in 1916. In the Pangani River valley, Smuts and his main force attempted to drive the German forces back southwards, but the enemy was elusive and he could never pin them down entirely. However, he declared victory in January 1917 after the Germans were driven out of German East Africa across the Rufiji River in Mozambique.

OPPOSITE, TOP Smuts at the railway line to Dar-es-Salaam next to his motorail truck in August 1916. The Department of Transport converted vehicles into motorail trucks to take supplies to the troops. The greatest cause of death among South African troops in East Africa was tropical disease, and the dead had to be transported to Dar-es-Salaam. Smuts himself contracted malaria and suffered from its ongoing effects for the rest of his life.

Soon after victory was declared in East Africa, Botha asked Smuts to represent the Union at the coming Imperial War Conference and the deliberations of the imperial war cabinet in London. Below, seated in the front row, third from the left, he is shown as a young general among the leaders in March 1917. The newly elected British prime minister, Lloyd George (not in this photo), noticed the talented Smuts and later asked him, on the recommendation of Winston Churchill, to serve in the British war cabinet.

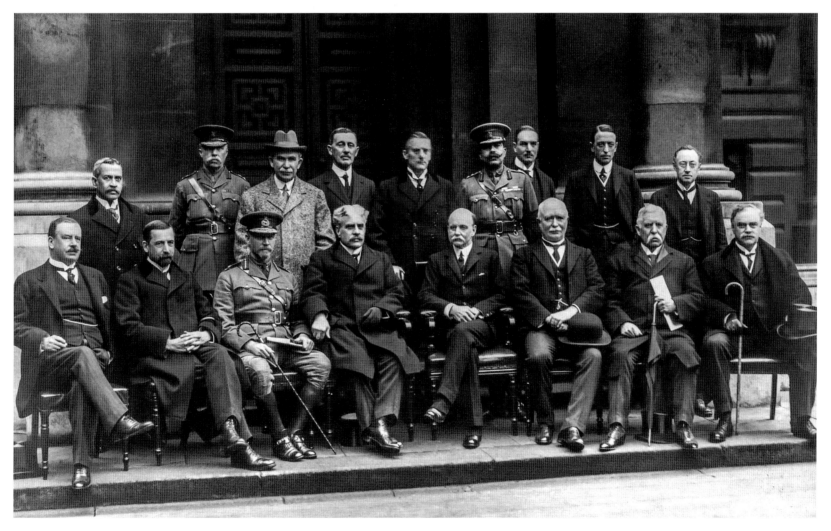

In May 1917, as a mark of respect for his role in the war, Smuts was granted the freedom of the City of London. At an event hosted by the City of London Volunteers and held at the famed Guildhall, he was introduced as "General Smuts, once our redoubtable and chivalrous foe … and now our staunch and close friend".

In January 1919 with Prime Minister Lloyd George on their way to the peace conference held at Versailles. In the successful debate on Smuts's suggestion that a League of Nations be established, this fiery Welshman was Smuts's staunchest supporter. Smuts also took the lead in promoting the mandate system for the management of conquered German territories. The upshot of this was that South West Africa was declared a C mandate and was placed under South African administration.

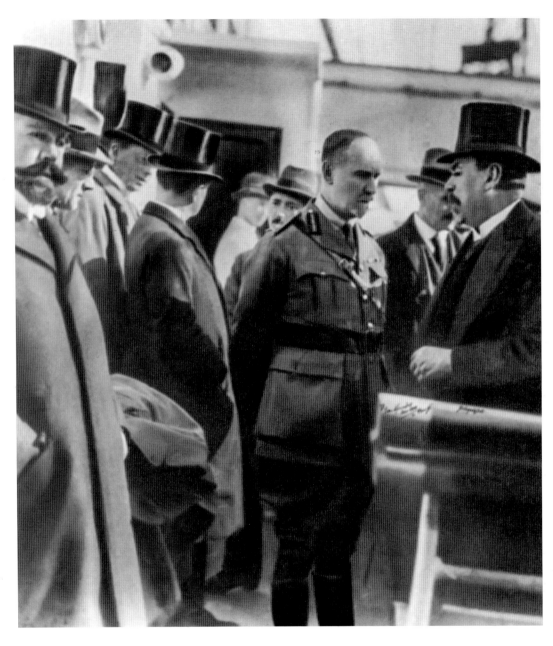

Smuts, Botha and Sir David de Villiers Graaff photographed at the Paris peace conference. Smuts, with the experience gained and concessions won at the Peace of Vereeniging between Boer and Briton, was initially reluctant to sign the Treaty of Versailles because he was critical of the strict conditions that were to be meted out to Germany. He predicted that these harsh measures would stir up resentment that might see Germany rise again in anger. De Villiers Graaff was brought in to reason with Smuts, after which he relented and co-signed the document with Botha. This was the first international agreement signed independently by the Union of South Africa rather than as a dominion under the British government, and as such was the beginning of a new era in the British Empire.

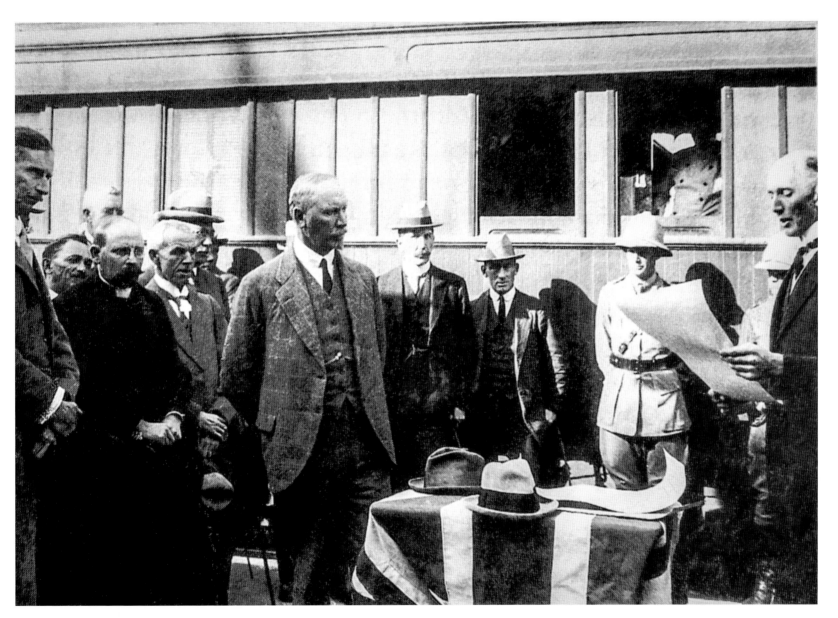

Here Smuts receives the C mandate of the League of Nations in 1919, empowering the Union to administer South West Africa on its own terms. However, the extent and the implications of this task were not fully realised at this stage. The ceremony took place in Paris beside the very same carriage where the truce with Germany was signed in 1918.

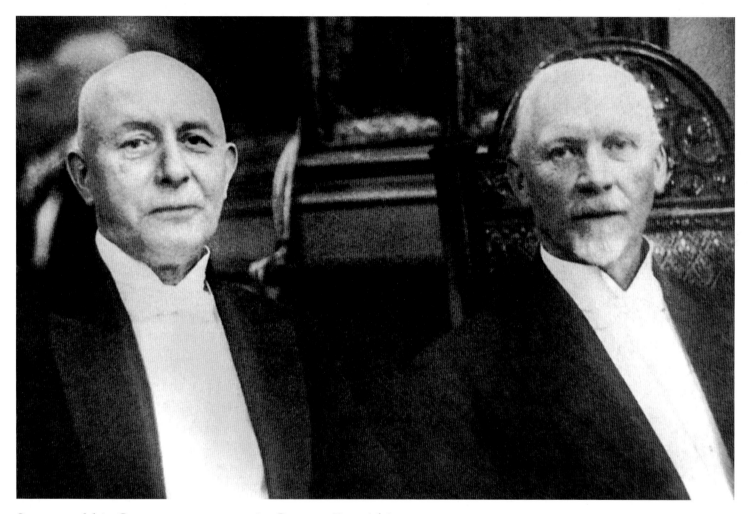

Smuts and his German counterpart in German East Africa, Gen. Von Lettow-Vorbeck, are photographed here on 15 November 1929 at a luncheon held in London for veterans of the East Africa campaign in World War I. In 1946, after World War II, Smuts visited the Von Lettow-Vorbecks in Germany where he found them living in conditions of abject poverty. After his visit, Smuts helped the family by providing them with food parcels, which they greatly appreciated. After the death of Smuts, Von Lettow wrote a heartfelt letter of condolence to Isie. Later, accompanied by his daughter, Von Lettow also visited Isie at Doornkloof.

From power to the "wilderness"
1919–1933

"We have not yet the whole, we have not yet a really unified South Africa, we have not yet attained to the unity which is our ideal. There is still too much of the old division and separation in our national elements, but still the effort has been made."

SMUTS RETURNED TO SOUTH AFRICA IN 1919 as a world-renowned statesman. Shocked by the untimely death of his comrade in arms, Louis Botha, only weeks after his return, he accepted the leadership of the South African Party and the premiership with reluctance, as he had been away from the country for three busy years and felt out of touch with politics and public opinion. At his first cabinet meeting, he warned colleagues that, unlike Botha, he had "neither tact nor patience" and they had to take him "for what I am worth".

In the post-war general election in March 1920, Smuts's SAP government lost ground to Hertzog's Nationalists. The SAP could only remain in power with the help of the pro-imperial Unionist Party led by Sir Thomas Smartt, which formally joined the SAP in November 1920. When Smuts called another election the next year, the new party won with a comfortable majority.

As prime minister, the tough-minded Smuts gave his political opponents and critics, at home and abroad, plenty of ammunition with the strict measures against local labour unrest and his sometimes too harsh government actions, for example during the strike of white miners in 1922. In the election of 1924, notable for the bitterness of the personal attacks on Smuts, his government was ousted by a coalition of Nationalists and the Labour Party, in which differences over racial policies between the two sides were a significant factor.

After briefly considering retirement, Smuts returned to parliament as the leader of the opposition. Free of the burdens of office, he found time to read, think and write. He was able to complete the manuscript of *Holism and Evolution*, a book he had begun writing many years earlier, in which he set out the philosophy by which he lived and was guided in his political career. Albert Einstein and other scientists commented favourably on the theory of holism, though a few academics were less impressed.

South Africans went to the polls again in 1929 in an election where Smuts and Hertzog clashed heatedly over colour policy. Winning a 17-seat majority in parliament, the National Party no longer needed the support of Labour. Disillusioned by the thought of another five years in opposition, Smuts took refuge in walking, mountaineering and pursuing his favourite hobby of plant collecting.

By invitation, he travelled to Oxford to deliver a series of Rhodes Memorial Lectures on, among other subjects, "world peace" in 1929. In 1931, Smuts was invited to be president of the British Association for the Advancement of Science in its centenary year – a rare honour for any foreigner. His book on holism played a major part in this homage.

Soon after the 1929 election, South Africa began to feel the ill effects from the collapse of Wall Street in the US and the ensuing economic depression that engulfed the world. When the British government abandoned the gold standard, Smuts, from London, pleaded unsuccessfully with Hertzog to follow suit.

With South Africa's worst drought in living memory causing a slump in agricultural production, putting thousands out of work, Smuts sensed that the political mood among the electorate was shifting. When Hertzog, after 15 months of economic misery, finally took South Africa off the gold standard, he began to put out feelers to Smuts about political cooperation in the national interest. In February 1933, Hertzog surprised parliament by announcing that he and Smuts had agreed to form a coalition government, based upon a seven-point set of principles. In the following parliamentary election in 1933, the coalition government won the election by a landslide. This led to the eventual fusion of the South African Party and the National Party to form the United Party on 5 December 1934, with Hertzog as prime minister and Smuts as his deputy. After twenty years of bitter rivalry, the breach between Smuts and Hertzog seemed to have been healed. ✒

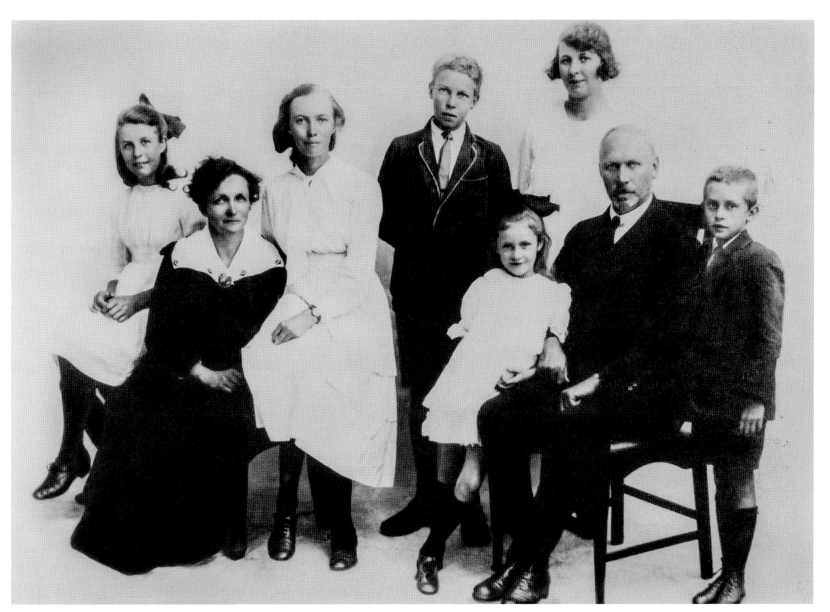

The Smuts family in 1919. From left to right: Sylma, Isie, Santa, Japie, Louise, Cato, Jan and Jannie. This photo was taken when Smuts was already prime minister, after his friend and colleague Louis Botha's death.

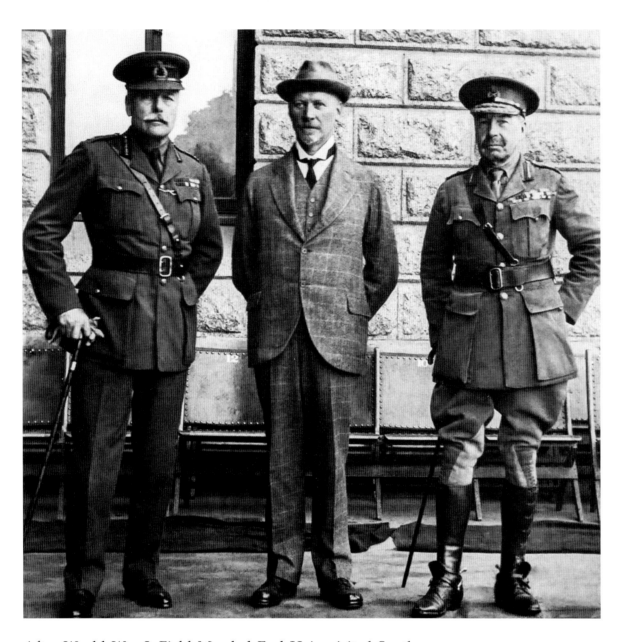

After World War I, Field Marshal Earl Haig visited South Africa. On 28 February 1921, Smuts and Gen. (Sir) H.T. Lukin joined him at the first conference of the British Empire Service League held at the Cape Town City Hall. Haig (left) was commander-in-chief of the British expeditionary forces at the Western Front in Europe during the war and Gen. Lukin was advisor to Smuts and co-founder of the Union Defence Force in 1912.

Smuts loved the mountains and few things gave him more pleasure than climbing up Table Mountain and looking out into the distance over his beloved Swartland. He loved climbing for the physical exercise, but also found solace and spiritual inspiration on the rugged mountain tops. In a speech presented at the Mountain Club of South Africa's war memorial service at Maclear's Beacon, he said: "The mountain is not merely something eternally sublime. It has a great historic and spiritual meaning for us. It stands for us as the ladder of life. Nay, more, it is the great ladder of the soul, and in a curious way the source of religion. From it came the Law; from it came the Gospel in the Sermon on the Mount. We may truly say that the highest religion is the Religion of the Mountain."

Relaxing on the rocks at Muizenberg in 1924 after a cold winter swim.

As an avid mountaineer, Smuts climbed every peak imaginable in the Western Cape. Table Mountain was among his favourites and it is said he climbed it more than 300 times. This image taken on the Table Mountain trail served as inspiration in 1938 for one of the two statues of Smuts in Cape Town. He was further honoured when a mountain peak in the magnificent Canadian Rockies range in Alberta was called Mount Smuts.

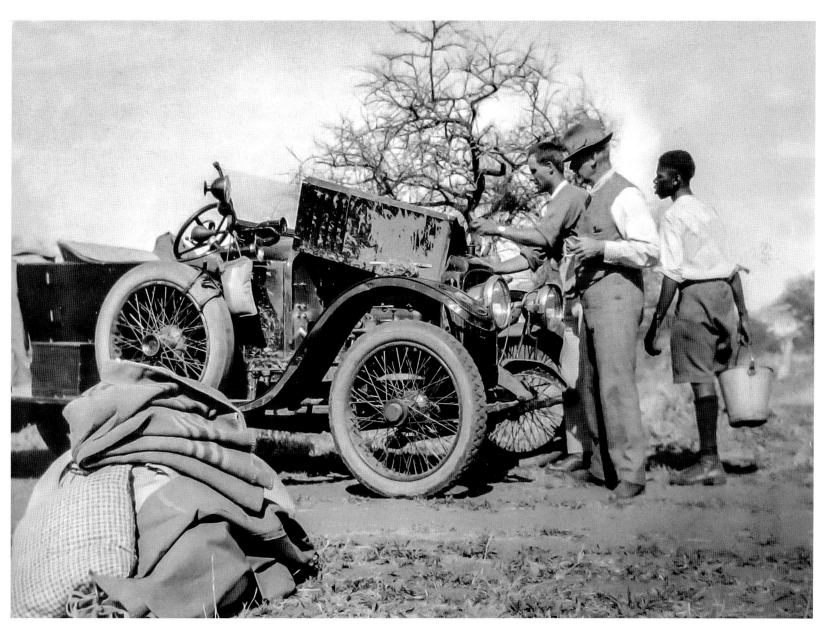

Smuts having car trouble in 1925 while en route to his farm Rooikop in the midst of the rainy season. His farm manager is helping, while an interested bystander looks on.

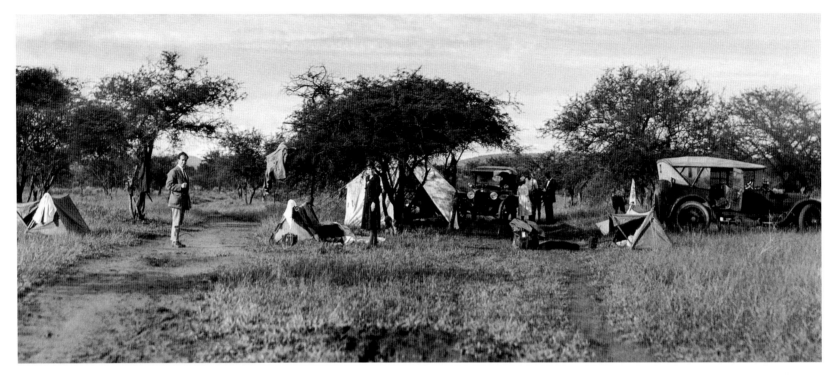

Early in 1920 Smuts began farming with cattle on his Bushveld farm, Rooikop. Before the farmhouse was completed in 1930, the family camped out under the sickle bush trees. They lived in rather primitive conditions for a considerable time.

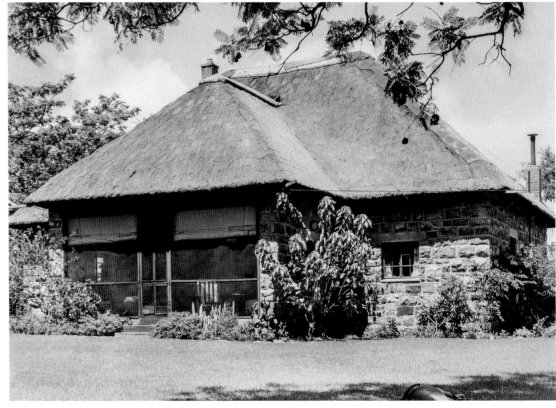

The thatched-roof house was built with local rock and local thatch.

During the building of the house with his son-in-law, Andries Weyers (Santa's husband), and his boys Jannie and Louis.

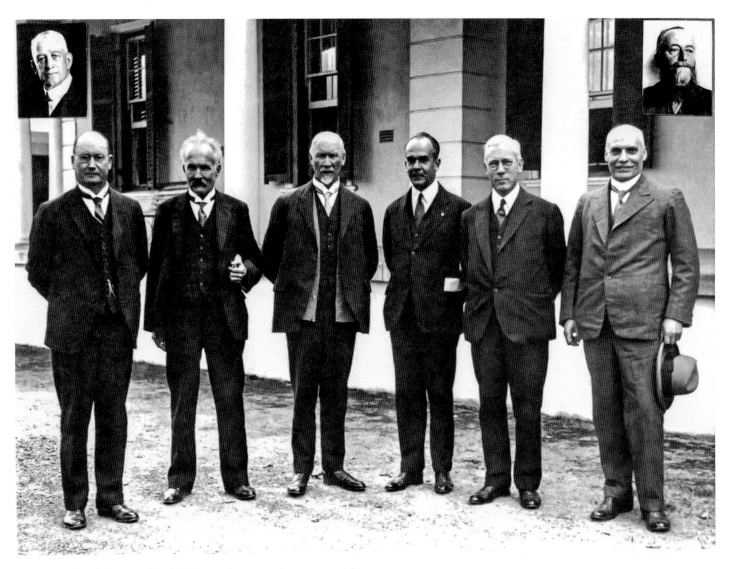

Smuts (third from the left) receives an honorary doctorate from the University of Stellenbosch on 24 June 1931. The other recipients (from left to right) are Dr D.F. Malan, C.J. Langenhoven, Dr P.J. du Toit, Dr H.J. van der Bijl and F.S. Malan. Inserts: Chief Justice J.H. de Villiers (left) and Dr N.J. Mansvelt (right).

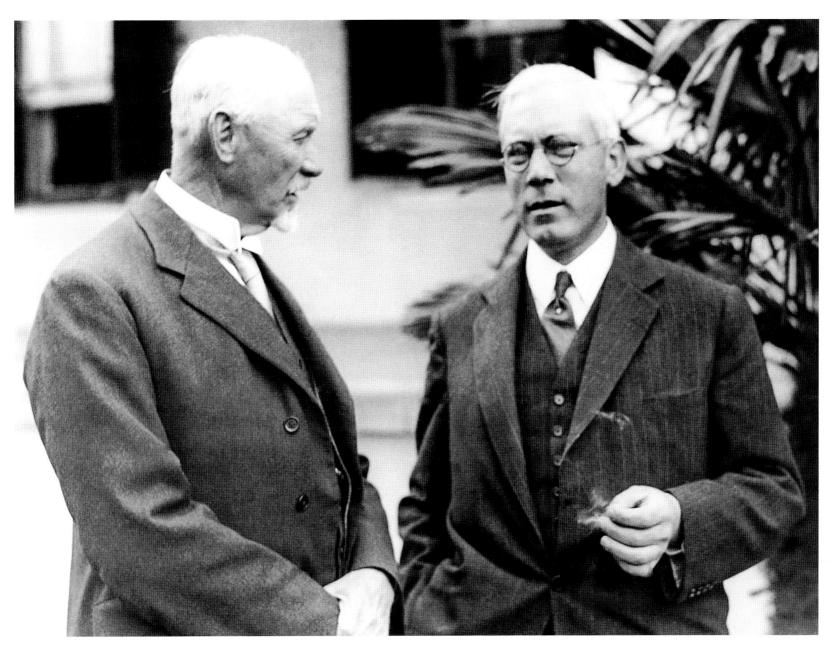

On the same day Smuts and Dr Hendrik van der Bijl discussed expanding the electricity supply (Eskom) and Iscor in South Africa. After Smuts's term as chairperson of the Imperial Industrial Priority Committee during the war, he was more aware of the shortcomings in South Africa as far as industrial development was concerned. He recruited Van der Bijl in 1919 as advisor to the government on the provision of electricity countrywide. Van der Bijl achieved great success in setting up the profitable Eskom and later also Iscor's iron and steel factories. In doing so, he stimulated the industrial revolution in SA's manufacturing sector. He was also involved in establishing a national system of electrified railways.

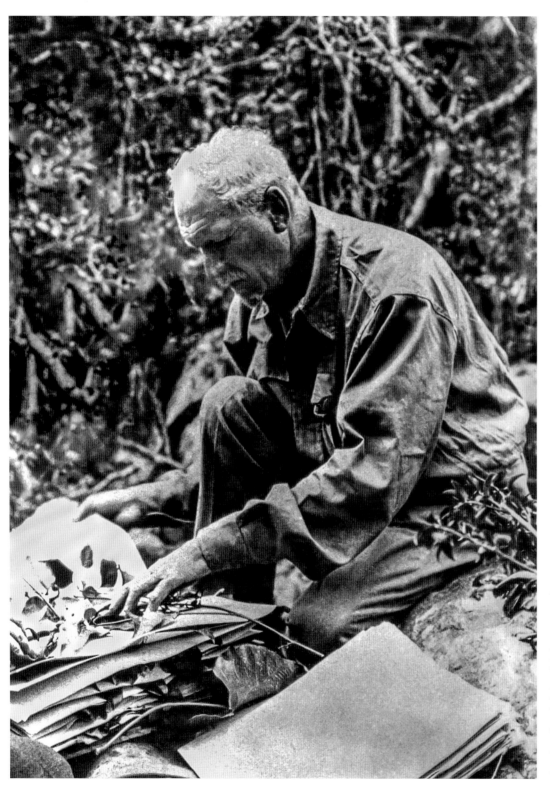

Smuts was knowledgeable about grass species, especially those indigenous to southern Africa. He often took time to gather botanical specimens and even did so during his war campaigns in German East Africa and the Egyptian desert in North Africa. Here he studies a specimen while on a field expedition. He had a well-maintained herbarium at Doornkloof which he indexed meticulously with the assistance of Dr Harriet Bolus of the Cape Herbarium of UCT. This collection was later transferred to the National Botanical Gardens in Pretoria.

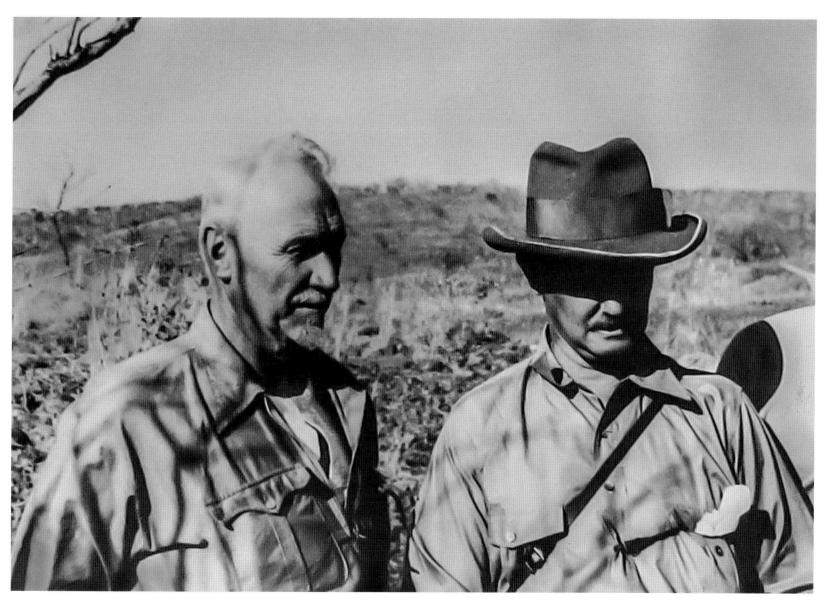

With his friend, neighbour and botanist, Dr I.B. Pole-Evans, head of the Department of Botany and director of the Botanical Survey of South Africa in 1926. Smuts recruited him from the Royal Botanic Gardens, Kew, to improve the pasturage of the Union and together they went on many field expeditions. A grass species is named after him: the Smuts finger grass.

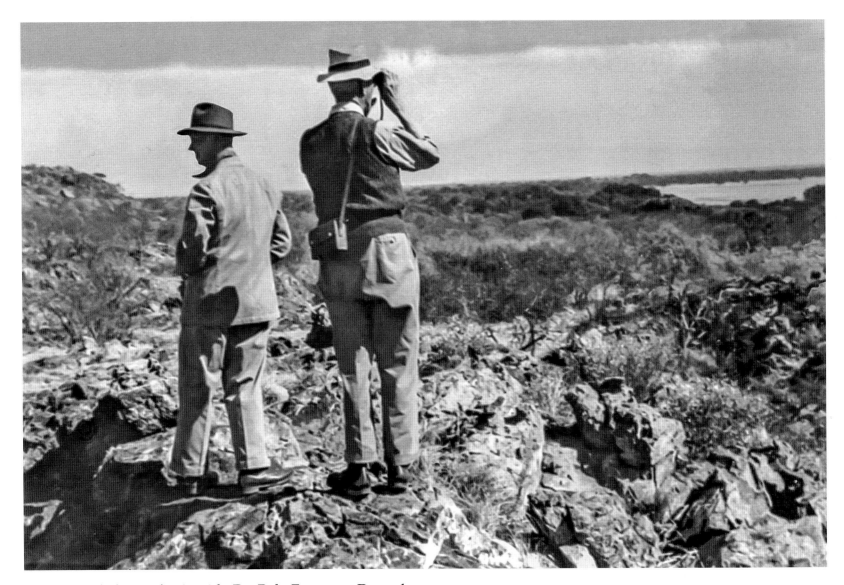

Smuts (with binoculars) with Dr Pole-Evans at Dongola, beside the Limpopo River. The purpose of the trip was to inspect the work of archaeologists at Mapungubwe on the farm Greefwald, Vhembe, in 1934. Smuts enjoyed the wide-open spaces every bit as much as the mountains. As he once put it: "Give me the open spaces, a hard bed, plain food, the stars above me, the birds, the flowers, and the wind in the trees."

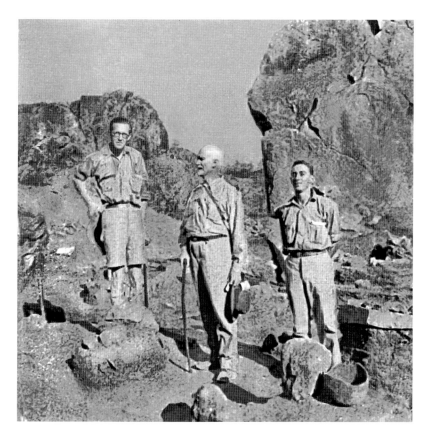

Smuts had a keen interest in archaeology and supported the findings of Prof. C. van Riet Lowe at Mapungubwe. He understood the importance of this archaeological terrain and was instrumental in the proclamation of this area as a heritage site in 1934. Here he is photographed in June of that year on Greefwald with Van Riet Lowe (left) and another member of the team, a Mr Van Tonder.

The worldwide depression which began in 1929, the drought in South Africa in 1930, and Hertzog's obstinacy in 1931 to leave the gold standard and convert to the sterling exchange rate, meant that the popularity of the Hertzog government declined. Here Smuts and Hertzog are seen in deep discussion because Hertzog's cabinet was in a precarious situation. The coalition and later fusion of parties to form the United Party resulted in the establishment of a new government.

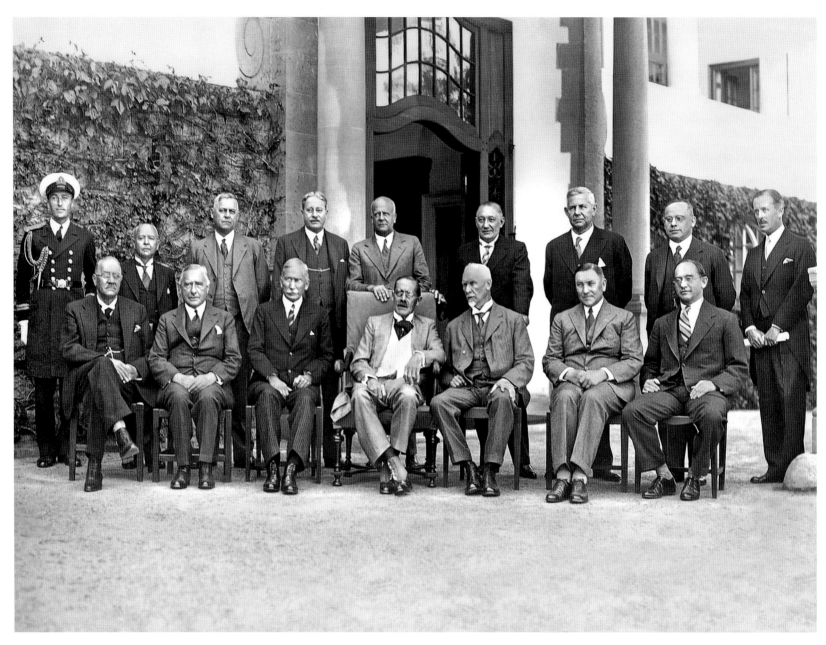

The coalition cabinet on 31 March 1933. *BACK (LEFT TO RIGHT)* Two officials, Sen. C.F. Clarkson (minister of posts and telegraphs, and of public works), R. Stuttaford (minister without portfolio), Col. D. Reitz (minister of lands), J.C.G. Kemp (minister of agriculture), A.P.J. Fourie (minister of labour, and commerce and industry), J.H. Hofmeyr (minister of the interior, public health, and of education) and an official. *FRONT (LEFT TO RIGHT)* P.W.G. Grobler (minister of native affairs), P. Duncan (minister of mines), J.B.M. Hertzog (prime minister and minister of foreign affairs), Lord Clarendon (governor general), J.C. Smuts (deputy prime minister and minister of justice), N.C. Havenga (minister of finance), O. Pirow (minister of railways and harbours, and of defence).

Smuts and Hertzog formed a new party. On 5 December 1934 the United Party was founded, a natural consequence of the previous coalition government. Smuts described this fusion of parties, that would eventually lead to the establishment of a new government, as the "birth of a nation". After D.F. Malan, leader of the National Party in the Cape, walked out on Hertzog in disgust because he did not agree with his views and actions, he split from the party and formed his own Purified National Party in 1935.

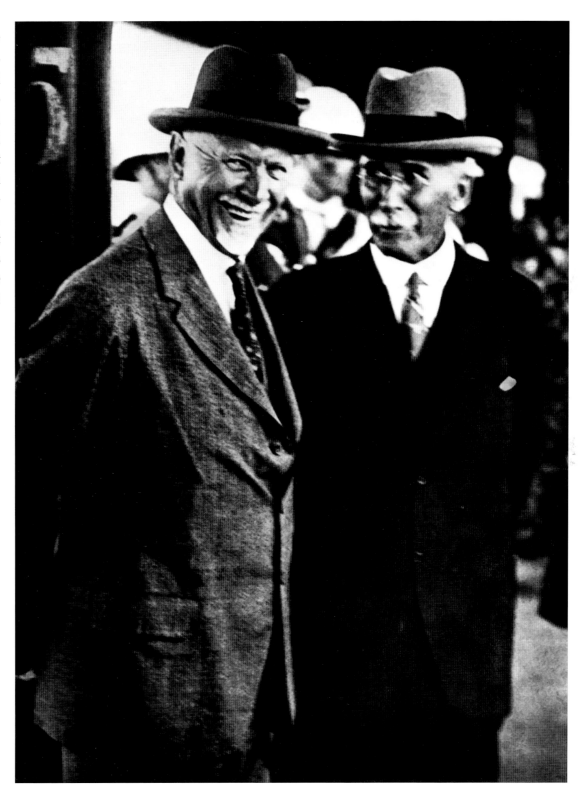

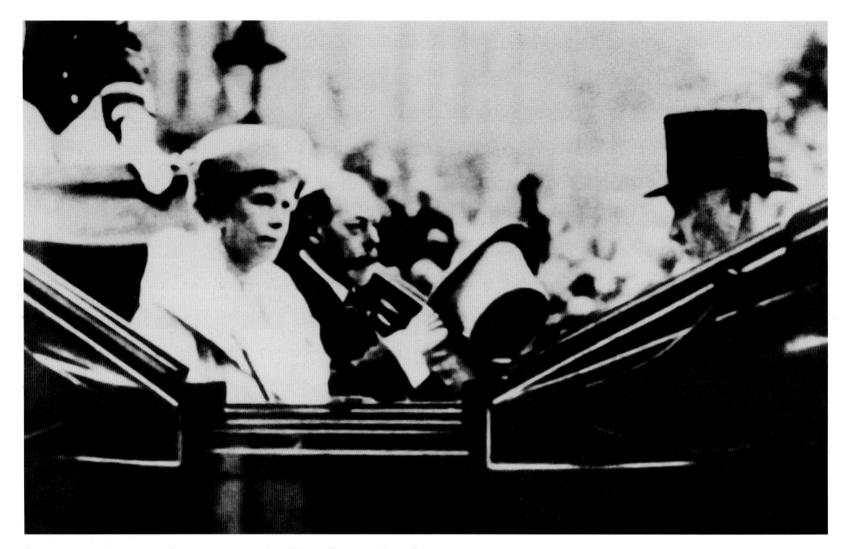

Smuts, wearing a top hat, accompanies King George V and his wife Mary in the royal coach on their way to the opening of South Africa House in London on 22 June 1933. After the death of Smuts, Churchill erected a life-size bronze figure of Smuts by the British sculptor Jacob Epstein on Parliament Square in Westminster. The statue was unveiled in November 1956. Although this was a great honour, the posture of the figure is very untypical of Smuts.

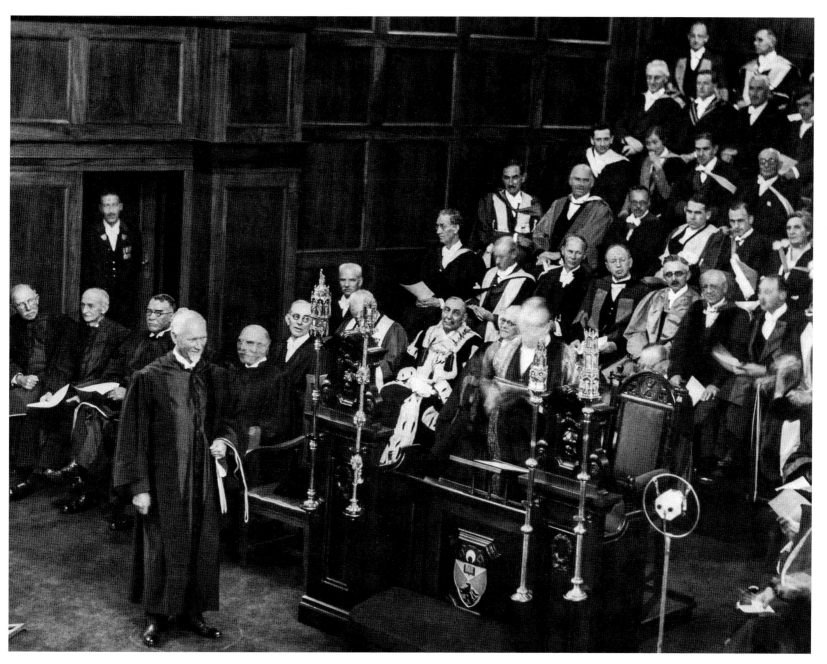

In his so-called "freedom" speech made at his inauguration as chancellor of St Andrews University in Scotland in October 1934, Smuts called upon Britain to take the initiative in Europe to oppose the destructive growth and aggression of Fascism and Nazism against democracy. Smuts's prediction at Versailles 15 years earlier was about to become a reality.

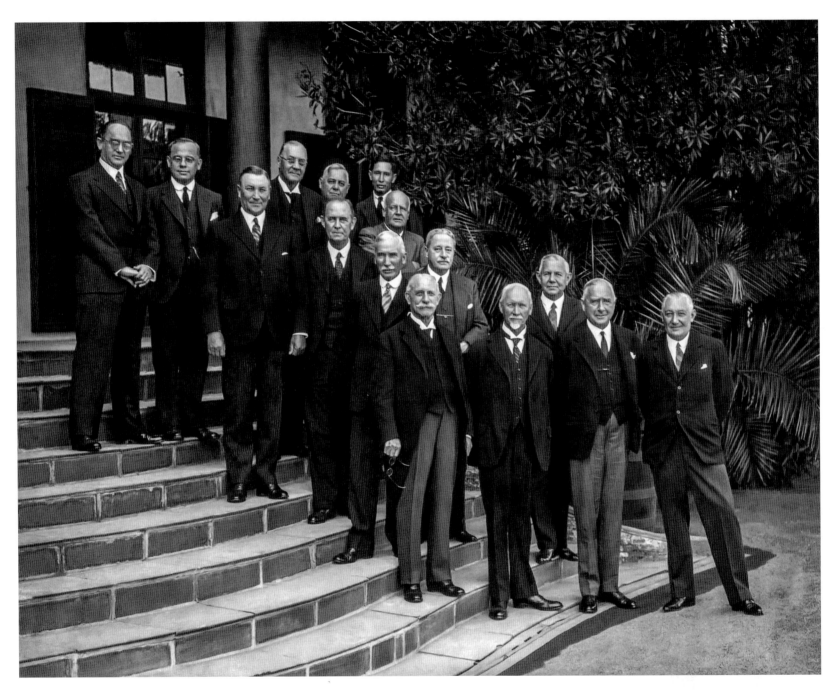

The ministers of the United Party in 1936. *FROM LEFT TO RIGHT*
O. Pirow, J.H. Hofmeyr, N.C. Havenga, Piet Grobler, Senator
C.F. Clarkson, Spies, Judge H.S. van Zyl, Col. D. Reitz, Hert-
zog, R. Stuttaford, Chief Justice (Sir) J.W. Wessels, Smuts,
A.P.J. Fourie, Patrick Duncan, Gen. Kemp.

War and peace
1933–1945

"Some of you will not come back. Some of you will come back maimed.
Those of you who do come back will come back changed men. That is war!"

THE UNEASY PEACE BETWEEN the United Party's two factions began to cause tension in 1936 over Hertzog's contentious "Native Bills", which Smuts voted for reluctantly in order to preserve party unity. However, the breach became permanent in 1939 over the issue of South Africa's participation in the war against Adolf Hitler's Third Reich. Hertzog wished the country to remain neutral, whereas Smuts believed South Africa had to fulfil its constitutional obligations to the Commonwealth, and would be drawn into the conflict anyway by the strategic importance of the sea route around the Cape. After a dramatic debate in parliament, Smuts's faction in the United Party defeated Hertzog's followers by 13 votes, and Smuts was invited by the governor general to form a new government. At the age of 70, he was prime minister again. On 6 September 1939, three days after Britain declared war against Nazi Germany, South Africa followed suit.

With vigour renewed, Smuts set about reviving the almost moribund UDF, which was in no condition to go to war. He had to act decisively: a make-shift coast patrol and air force had to be assembled hastily out of local resources, and the army's permanent force enlarged and reinforced by thousands of volunteers. Knowing how controversial conscription would be, Smuts dared only to recruit volunteers for service outside the country's borders. Another of his early moves was to appoint the managing director of Iscor, Dr H.J. van der Bijl, to oversee the manufacturing sector, which he did so effectively that South Africa became known as the "great repair shop of the Middle East". But as in World War I, Smuts found himself fighting on two fronts: against an external enemy in North Africa and an internal enemy in the pro-German "Stormjaers" (an activist minority group within the Ossewabrandwag), which embarked on an anti-recruitment and sabotage campaign.

When the Italian dictator Benito Mussolini joined forces with Hitler, SA troops went to war against Italy's possessions in North Africa. Springbok troops drove the Italians out of Abyssinia (today Ethiopia), before going on to support the Allied army in the Egyptian-Libyan desert, and thereafter in Italy itself. On Smuts's 71st birthday in May 1942, King George honoured his contribution to the Allied war effort by making him a field marshal in the British Army.

After the disastrous Allied loss of Tobruk to Field Marshal Erwin Rommel's Afrika Korps in mid-1942, Churchill invited Smuts to a meeting in Cairo to discuss a reshuffle of the British Army's top commanders in the Middle East in which General Montgomery was put in charge of the 8th Army. Visiting London for five weeks later that same year, Smuts was invited to the deliberations of the war cabinet and afforded the honour of being asked to address a joint meeting of both houses of parliament, at which he declared the defensive phase of the war to be over and the offensive phase about to begin – a message received with great enthusiasm around the Allied world.

Buoyed by the defeat of Rommel's forces by the 8th Army at El Alamein – in which South African forces participated – Smuts called an election in July 1943 and won an emphatic mandate from the electorate. The following May, he was back in Britain to witness the preparations for D-day. Six days after the successful invasion of France by the Allied forces, Smuts was invited by Churchill to accompany him on a visit to General Bernard Montgomery at his new headquarters at Bayeux in Normandy – the only Commonwealth premier to be invited. On his way home to South Africa, he stopped over to visit the South African troops fighting in Italy and to hold discussions with Field Marshal Harold Alexander.

Tiring though they were for a man of his age, Smuts's visits to Britain were a morale booster for him. He had been at the centre of world events, consulted by kings and queens, admirals, generals, businessmen and -women, and experts from all walks of life. The fractious politics of South Africa must have seemed a long way off, and comparatively trivial. ✍

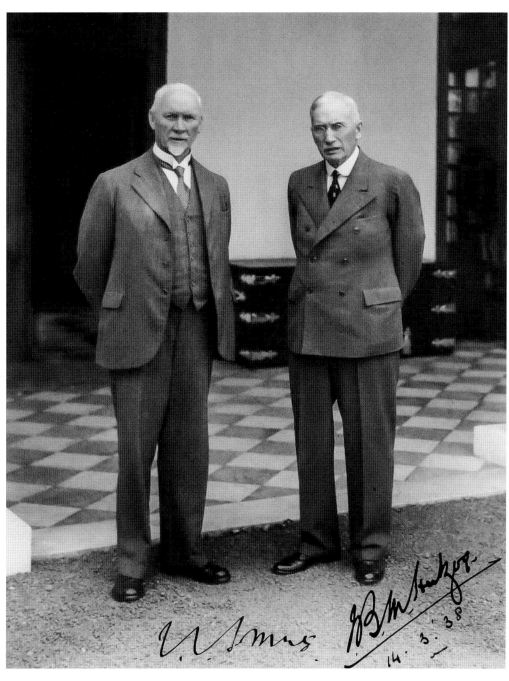

The founders of the United Party, photographed four years later in 1938. Smuts was deputy prime minister at the time, and Hertzog prime minister. Eventually, it would disintegrate as a result of differences about international matters and the colour issue.

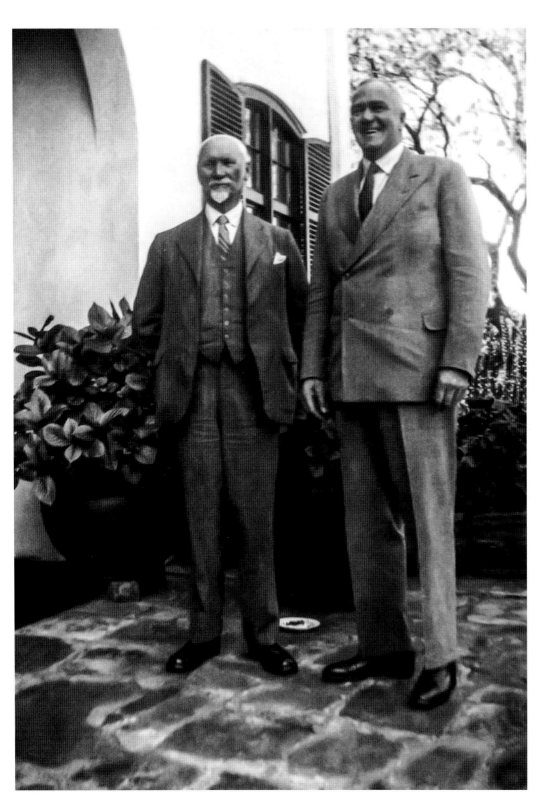

In 1939 with Louis Esselen, his good friend, the organiser and secretary general of the United Party. During the parliamentary debate on South Africa's participation or neutrality in the war against Germany in World War II, Esselen lobbied behind the scenes and organised a majority in favour of Smuts, who then became prime minister. Esselen was the only person, except possibly his sister Bebas in Hermanus (who was mayor of the town from 1941 to 1946), who could challenge Smuts on any subject. He retired from politics late in 1940 and became commissioner of railways.

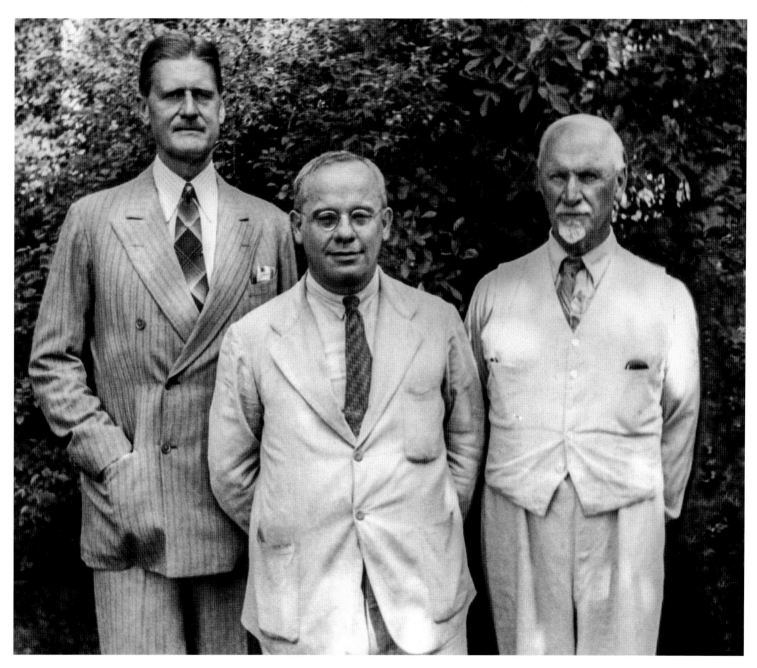

Smuts with two of his pillars of support in October 1939 – Maj. Piet van der Byl (minister of native affairs) and Jan Hofmeyr (deputy prime minister, minister of finance, and of education). They were photographed shortly after the outbreak of World War II.

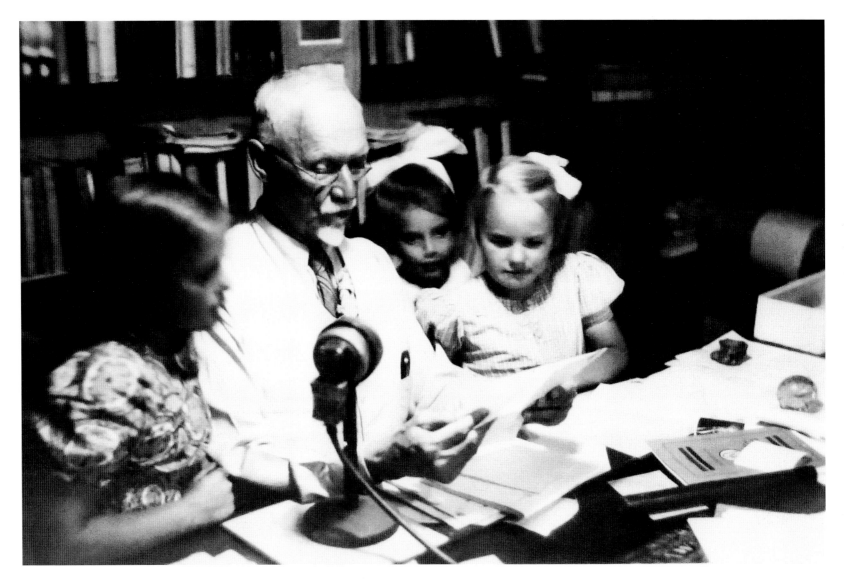

Surrounded by his granddaughters, Smuts presents his New Year's message on the radio from the library of his home on 1 January 1940. The grandchildren (from left to right) are: Cecile Weyers (born 1934), Sybilla Coaton (born 1932) and Lilian Coaton (born 1933).

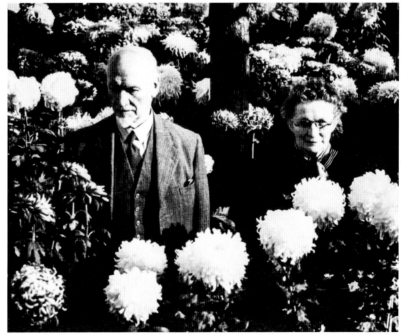

Smuts in 1942 in the gardens of Groote Schuur, the official home of prime ministers during parliamentary sessions in Cape Town. While serving five terms as prime minister, he resided here from 1919 to 1924 and again from 1939 to 1948.

Smuts and Isie among the flowers at Groote Schuur in 1945. At Doornkloof he wanted only trees and savannah grasses – and no flower gardens.

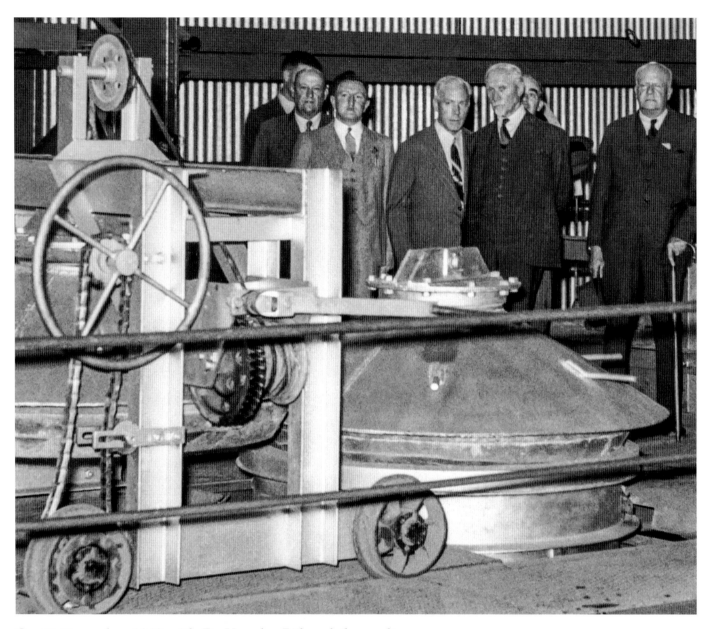

On 19 December 1940 with Dr Van der Bijl and the parliamentary committee responsible for the acquisition of war supplies during a visit to factories in Pretoria and surrounding areas. Here he is inspecting the heat treatment of howitzer barrel steel at the ordnance plant at Iscor. Owing to Smuts's vision 20 years earlier, the South African industry was ready for the rapid conversion to a war industry under the leadership of his trusted friend Van der Bijl.

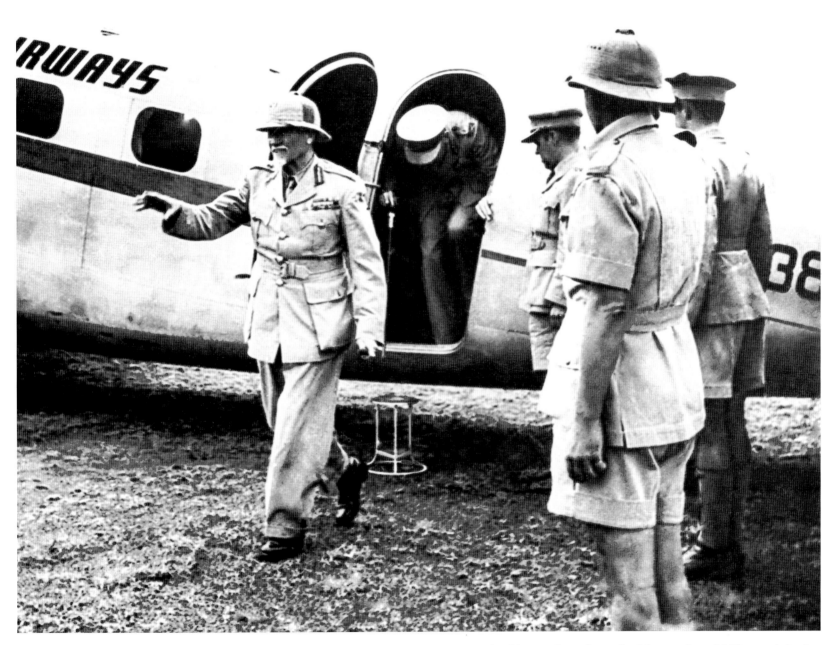

Arriving in Kenya by plane in November 1940 to visit the troops who soon afterwards defeated more than 200 000 Italian troops. A brand-new VIP airplane, an Avro York MW107 dubbed "Oubaas", was given to Smuts by Churchill for his personal use because of the great distance to Europe.

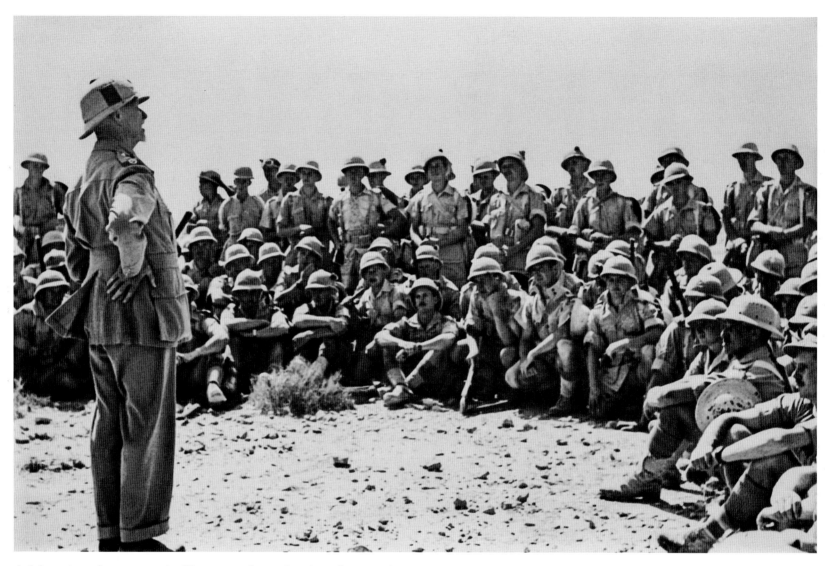

Addressing the troops in Kenya and motivating them prior
to their campaign in Abyssinia.

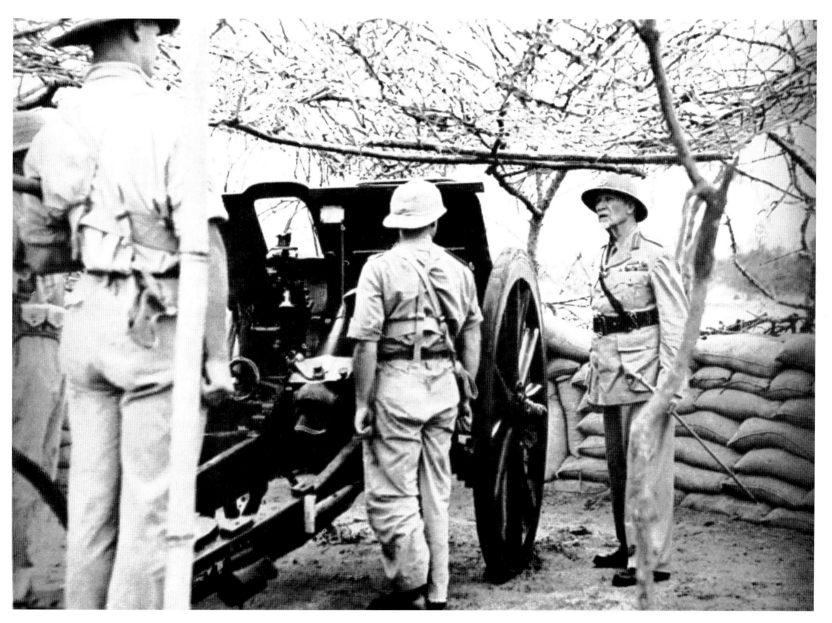

Smuts inspects the Transvaal Horse Artillery's gun emplacements in Kenya.

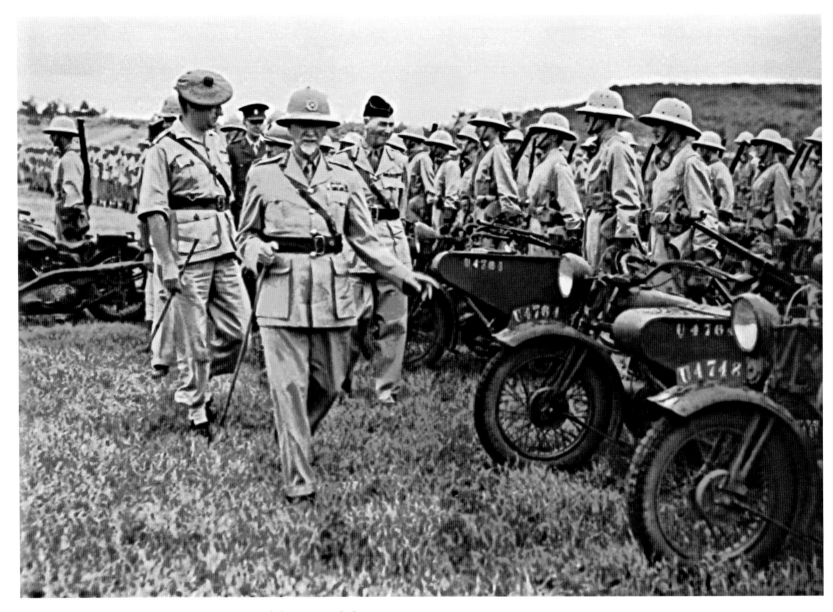

Smuts carries out an inspection tour of the motorbike troops
prior to their deployment to Abyssinia in November 1940.

Early in 1941, as commander-in-chief of the South African forces, here photographed in the drawing room of their Doornkloof home, Field Marshal Smuts points out to Isie "this is where our sons are fighting" and explains the strategy in East Africa.

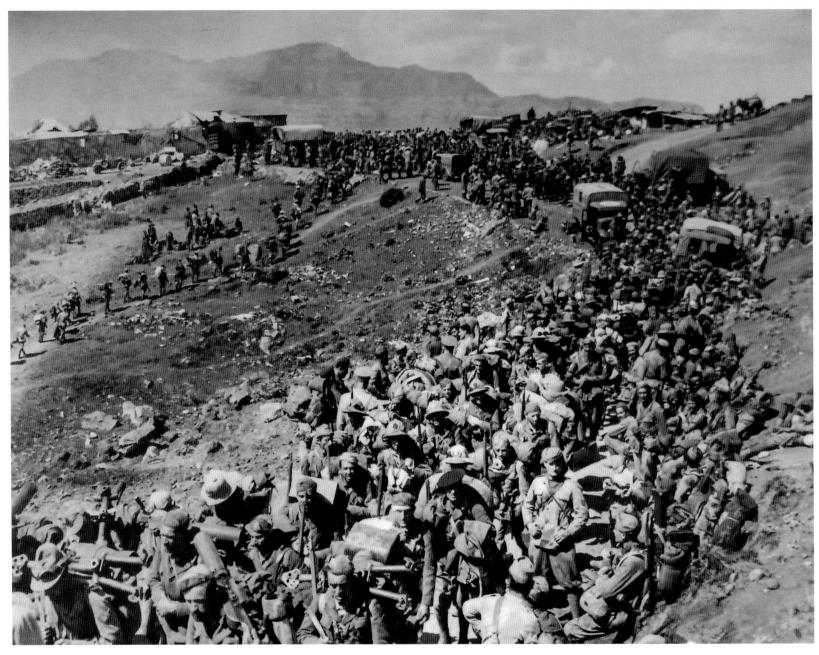

In the first Allied victory on 15 May 1941, more than 200 000 Italians surrendered to South African troops. After this, Smuts, as the successful commander-in-chief, was honoured by King George VI with the rank of field marshal, a title bestowed only during wartime. Thereafter he was addressed on the world stage as Field Marshal Smuts, but in South Africa he preferred the title "General" to retain the political rather than military balance.

OPPOSITE The official letter signed by King George VI.

BUCKINGHAM PALACE

22nd. July, 1941.

My dear Field Marshal,

 I was hoping to be able to present your Field-Marshal's Baton to you personally in England, but I well understand the reasons why you do not want to be away from South Africa for so long at the present time.

 I am therefore asking the Governor-General, as my personal representative in the Union, to hand the Baton to you on my behalf, and I would like you to know how proud we, your fellow Field-Marshals, are to count you among our number.

 With all good wishes,

Believe me

Yours very sincerely

George R.I.

Field-Marshal,
 The Right Honble. J.C. Smuts,
 C.H., F.R.S.

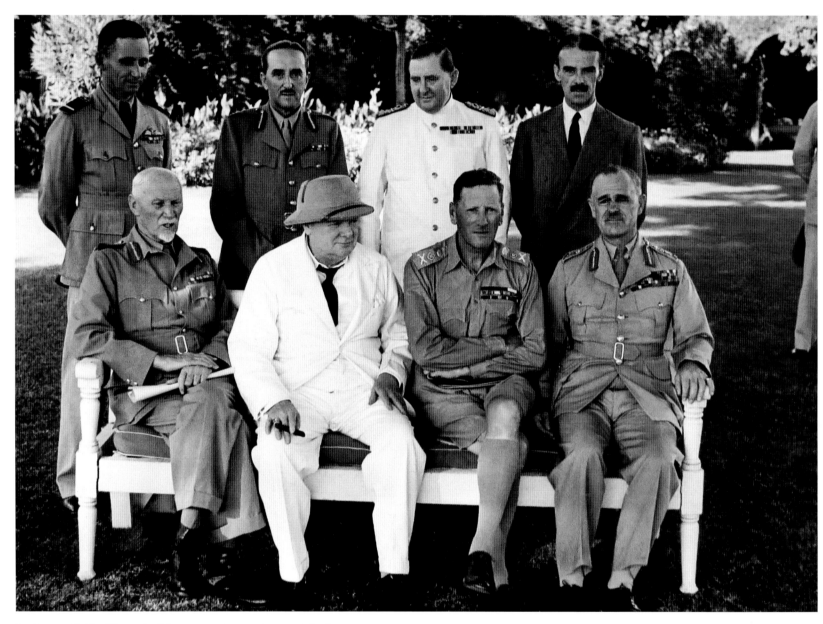

In June 1942, Churchill became impatient with the poor performance of the Allied forces against Rommel's German forces in North Africa. He organised a strategic planning conference for his war cabinet in Cairo, and Smuts was also invited. New plans and commanders were needed. Here, at the start of the conference, Smuts is photographed with Churchill and members of the Middle East War Council in the gardens of the British Embassy.

FRONT ROW (LEFT TO RIGHT) Field Marshal Jan Smuts, Sir Winston Churchill, General (Sir) Claude Auchinleck (commander, 8th Army) and Sir Archibald Wavell (commander of the Middle East Command). *BACK ROW (LEFT TO RIGHT)* Air Chief Marshal (Sir) Arthur Tedder, Sir Alan Brooke (head of Imperial General Staff), Admiral (Sir) H. Harwood and Richard Casey (representative of the Middle East War Council).

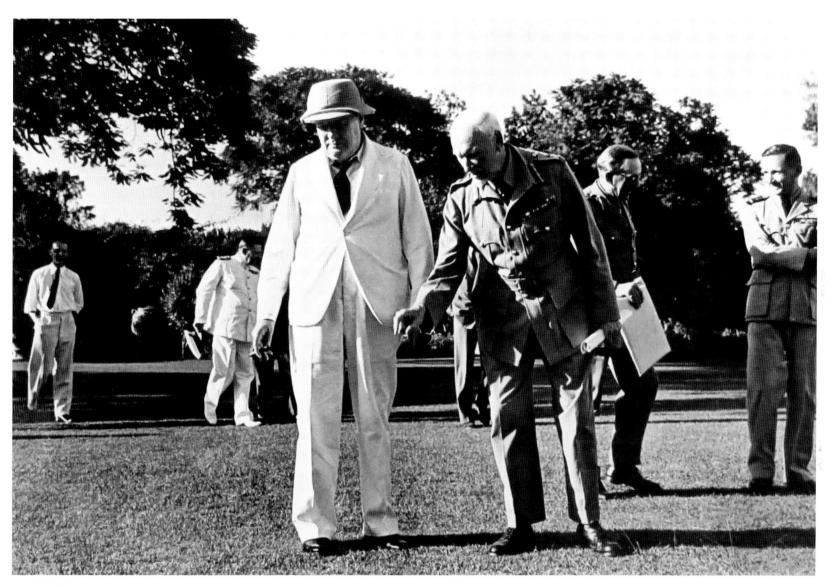

Smuts is photographed with Churchill, General Brooke and Air Marshal Tedder at the British embassy in Cairo during the same conference in 1942. During a break, after a difficult session, Smuts chats to Churchill about types of grass. In the background the other officers are looking on, relieved that the meeting is over. This conference was especially important because new commanders were appointed and a new strategy accepted for the Middle East that would lead to an eventual victory of the Allied forces in North Africa and mark a turn of the tide against the enemy.

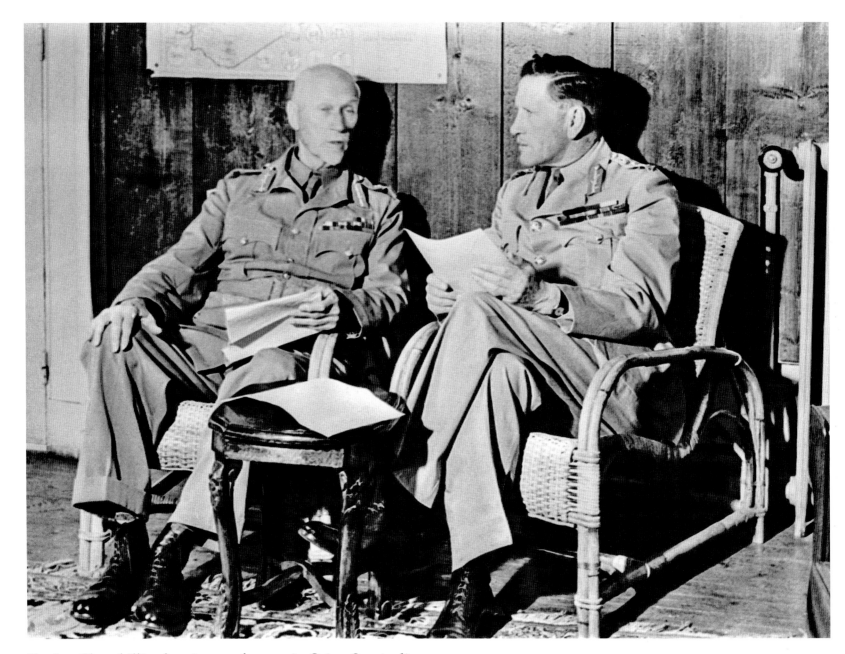

During Churchill's planning conference in Cairo, Smuts discussed the defence of Egypt with Gen. Auchinleck, at the time still commander-in-chief of the Allied 8th Army in North Africa. However, soon afterwards Auchinleck was replaced by the famed Gen. Bernard "Monty" Montgomery. The well-known Battle of El Alamein in Egypt followed, after which the offensive phase was launched successfully.

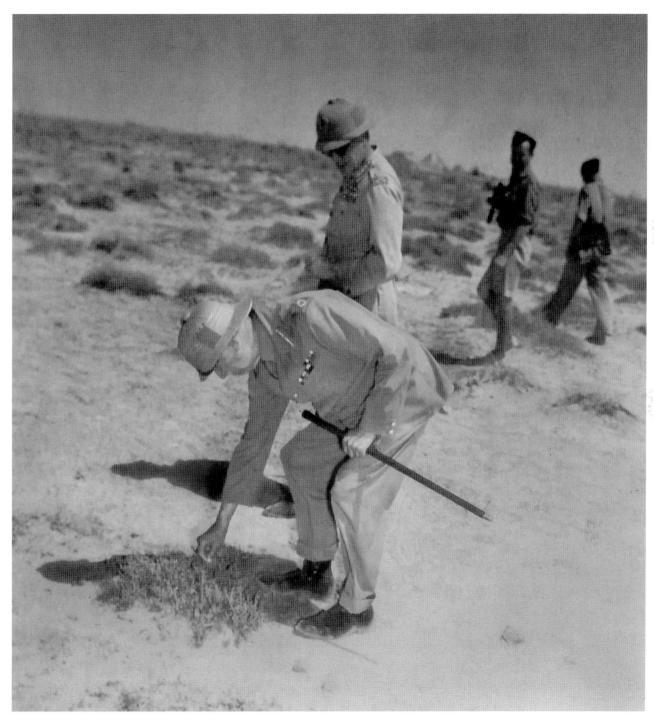

Smuts never missed an opportunity to indulge in his favourite hobby and showed great interest in the grass species of the western Egyptian desert.

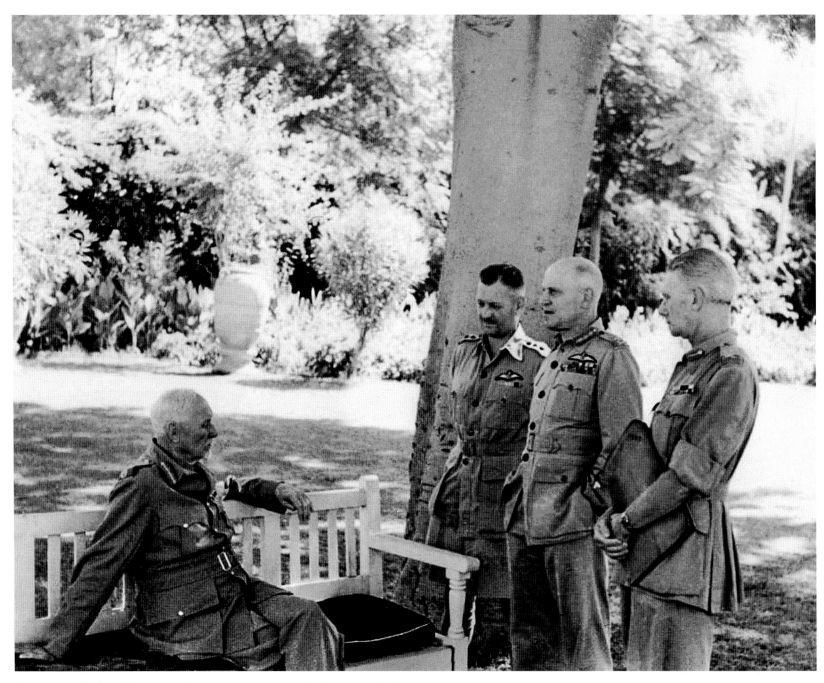

Smuts and Gen. Wavell, the most senior British general, in earnest discussion at the conference. Wavell (middle), the previous British commander-in-chief of the Middle Eastern and North African theatres of war was succeeded by Gen. Alexander who headed the Middle East Command.

OPPOSITE Smuts is shown here discussing strategy with generals I.P. de Villiers and Dan Pienaar in a desert caravan in the western desert of Egypt. Pienaar was the victorious commander-in-chief during the campaign earlier in Abyssinia against the Italian forces.

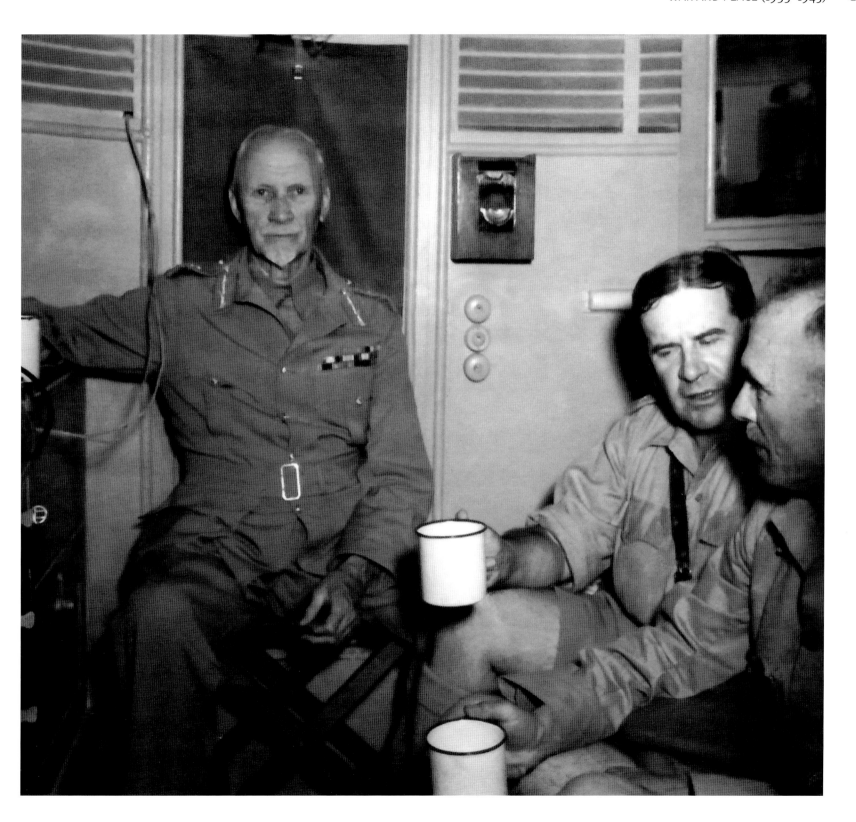

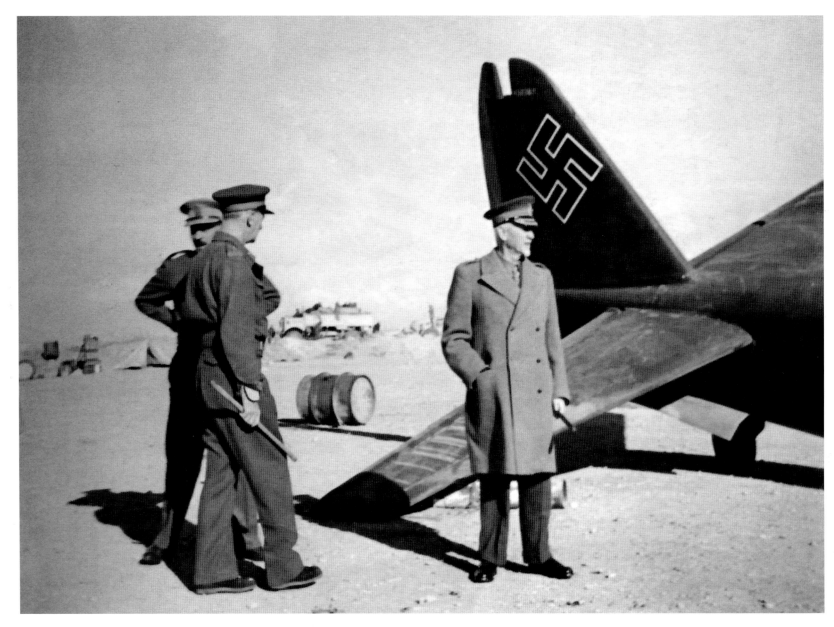

With fellow officers, Smuts looks at a German Junkers Ju 88 plane that was shot down at Mersa Matruh in the western desert before the Battle of El Alamein.

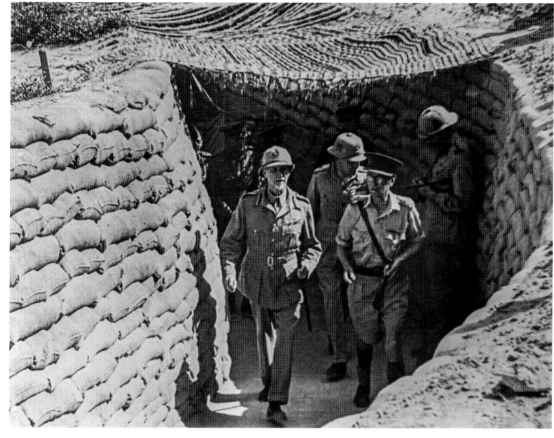

Smuts, Brig. Piet de Waal and Col. Verster, officer commanding of 8 SA CCS (Casualty Clearing Station), inspecting the field hospital at Mersa Matruh.

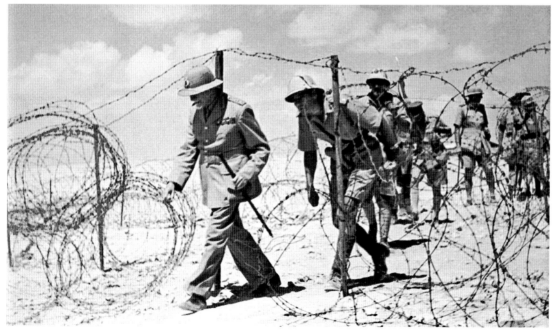

Here Smuts walks through the so-called "Devil's Garden" defence system set up by the troops of 3 SA Brigade at El Alamein in Egypt while on his visit to the western desert in June 1942.

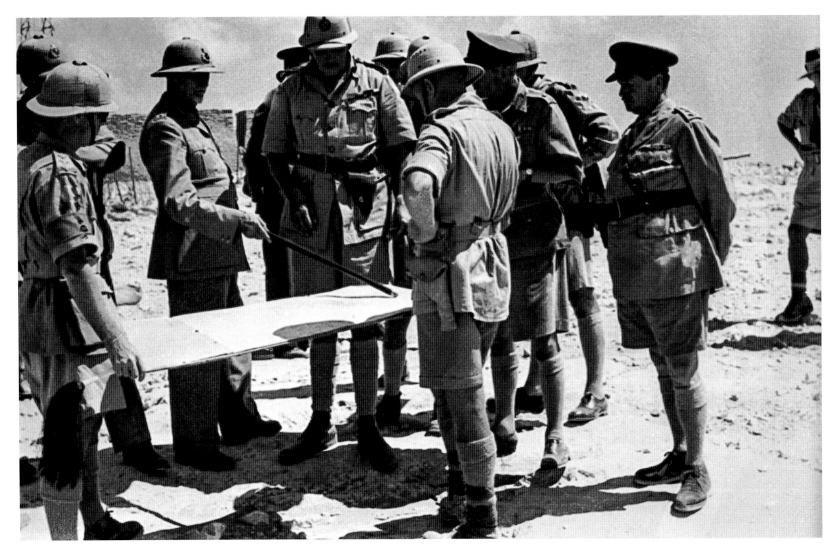

Smuts and a group of senior officers study a map and discuss their strategy. Smuts always made sure he was well informed and was in a position to give valuable input during high-level decision making.

OPPOSITE Looking out over the barren, deserted Bardia harbour which the Germans had used as an important submarine base. One of the most notable conquests in the military history of South Africa took place here in October 1942.

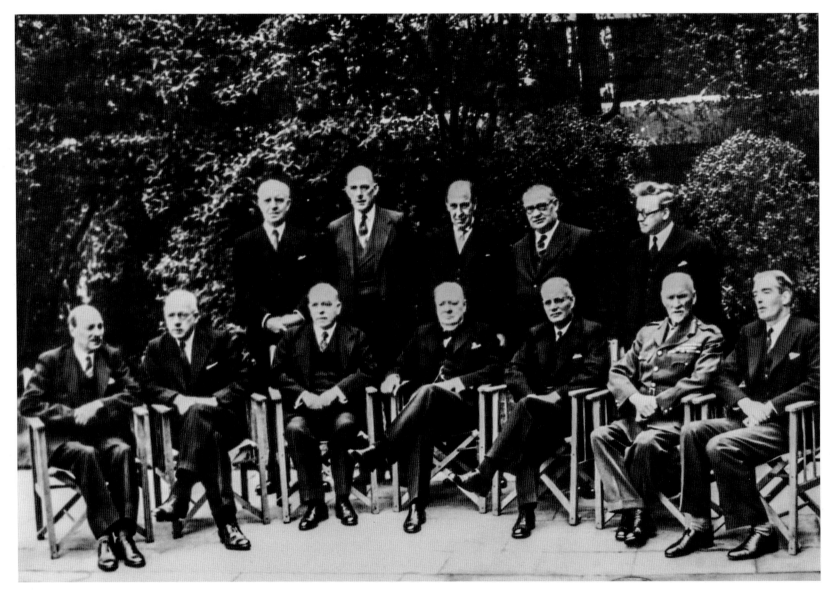

During both world wars, Smuts was a member of the British war cabinet, and during World War II he was part of the inner circle of the British command. Here he is photographed with Churchill's cabinet while on his first wartime visit to London in October 1942.

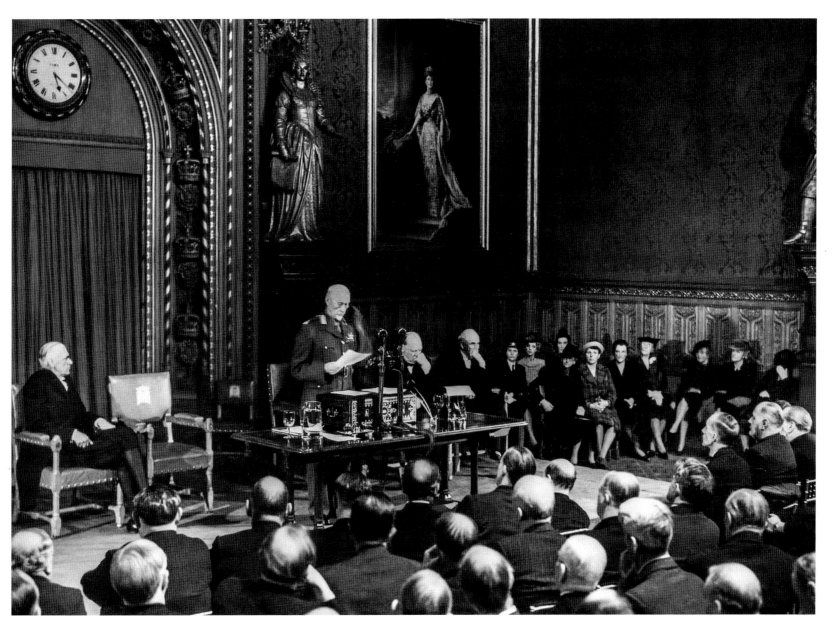

Addressing members of a joint sitting of both houses of the British parliament on 21 October 1942, his theme was "The Offensive Phase". Many see this as the highlight of Smuts's career. He was introduced by the former British premier, Lloyd George. From left to right at the table are Capt. E.A. Fitzroy (the Speaker of the House of Commons), Smuts, Churchill and Viscount Simon (the Lord Chancellor). Lloyd George is seated behind Smuts.

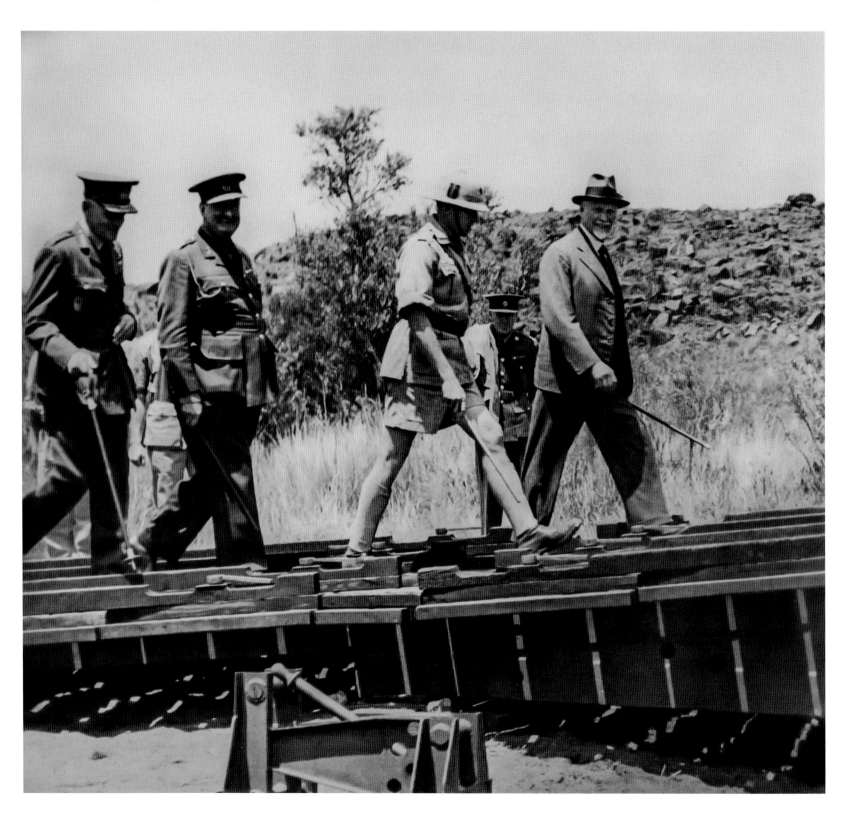

OPPOSITE Smuts is photographed while supervising the training of engineering troops at Zonderwater outside Pretoria. The men were preparing for combat in Italy in March 1943. These SA troops built 30 bridges in 30 days during the campaign, and undertook a daring crossing of the Po River. Later the engineers involved in this remarkable achievement received two additional Oak Leaves from the British monarch which were then displayed on their regimental badges. Walking across the same bridge (from left to right) are: Lt. Gen. (Sir) Pierre van Reyneveld, head of General Staff, Col. H.J. Cotton, director of the SA Army Engineer Corps, Capt. E.T. Dobson, the commander of Engineers Camp, and Prime Minister Smuts.

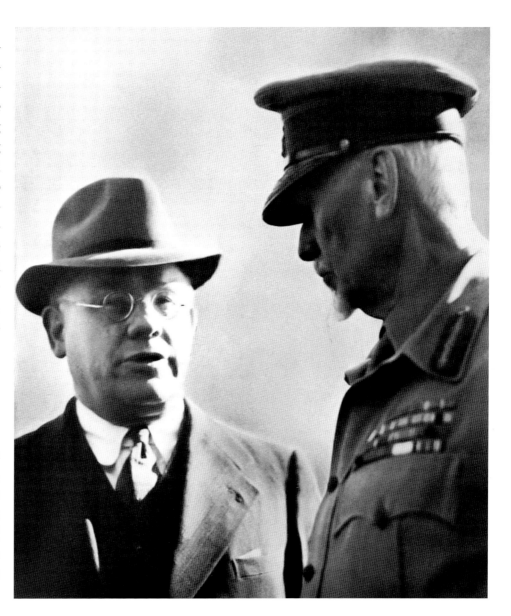

Smuts in serious discussion with his second in command and confidant, Minister Jan Hofmeyr, before he left for Cairo in July 1943 from the Swartkops Airport in Pretoria. Hofmeyr often had to deputise for Smuts during the war and here they exchange final thoughts before the parliamentary election that was just around the corner.

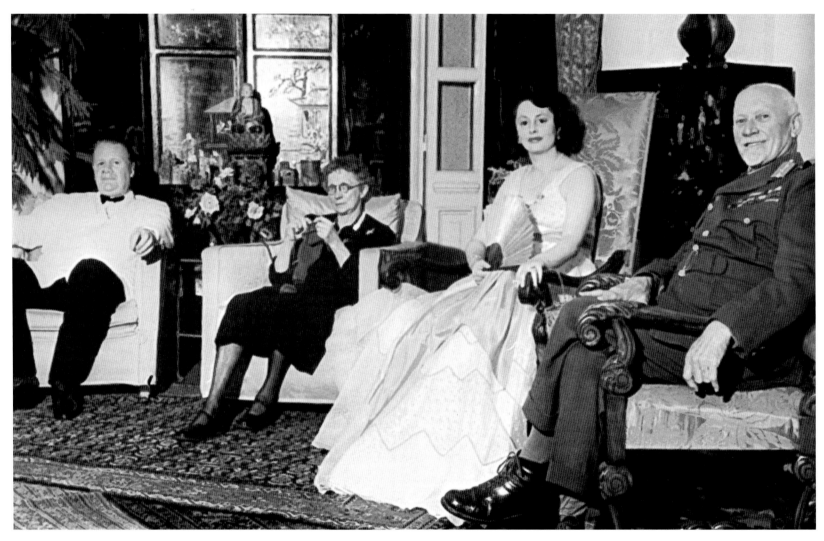

As prime minister of South Africa on a visit to Egypt with Isie in July 1943. Here they are in the British Embassy in Cairo with the ambassador and Lady Lampson.

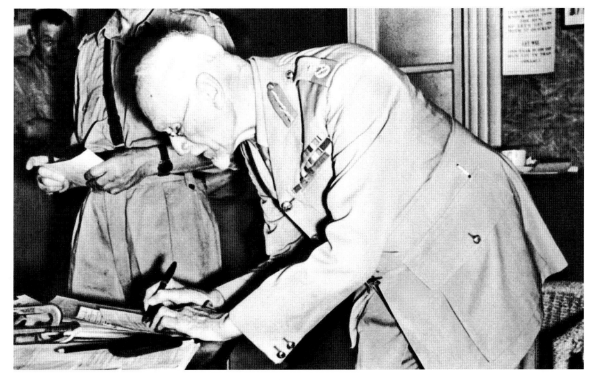

At the polling booth at head-quarters in Cairo, Smuts casts his vote in the South African parliamentary election of 7 July 1943. The election was announced in May of that same year after the German invasions at El Alamein (in October the previous year) and Stalingrad (in February) were repulsed. The military success of the Allied forces had a positive influence on local political sentiment in South Africa and Smuts gained influence as a proactive member of the victorious Allied forces.

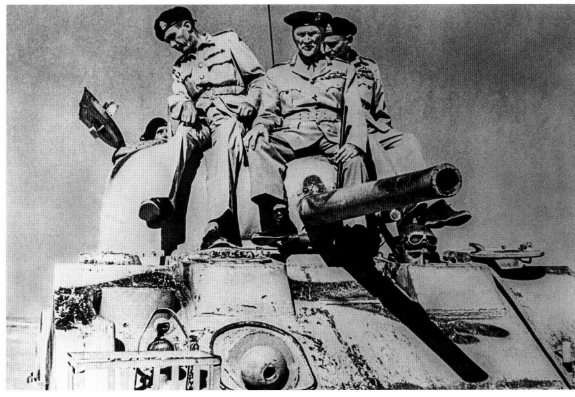

In the same month Smuts took delivery of a number of Sherman tanks from the United States in preparation for use by the newly formed 6th SA Armoured Division in North Africa in the upcoming campaign in Italy. Sitting on one of the tanks during the inspection parade are Gen. W.H. Evered Poole, division commander, and Smuts.

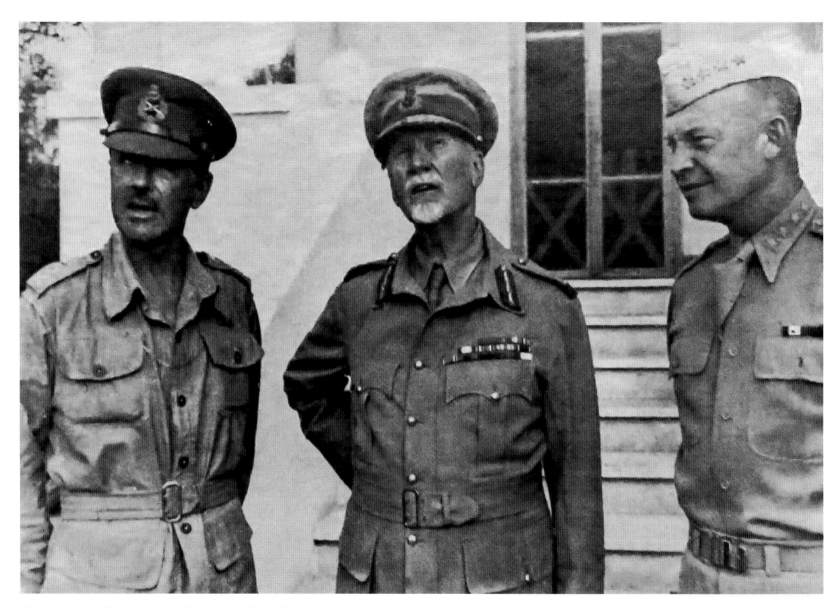

En route to London in October 1943, Smuts met Gen. D. Eisenhower (later president of the United States), who was commander of the US troops, at Thunis. He is accompanied here by Field Marshal Alexander (left), commander-in-chief of the Middle East Command, who later also headed the Italian Command.

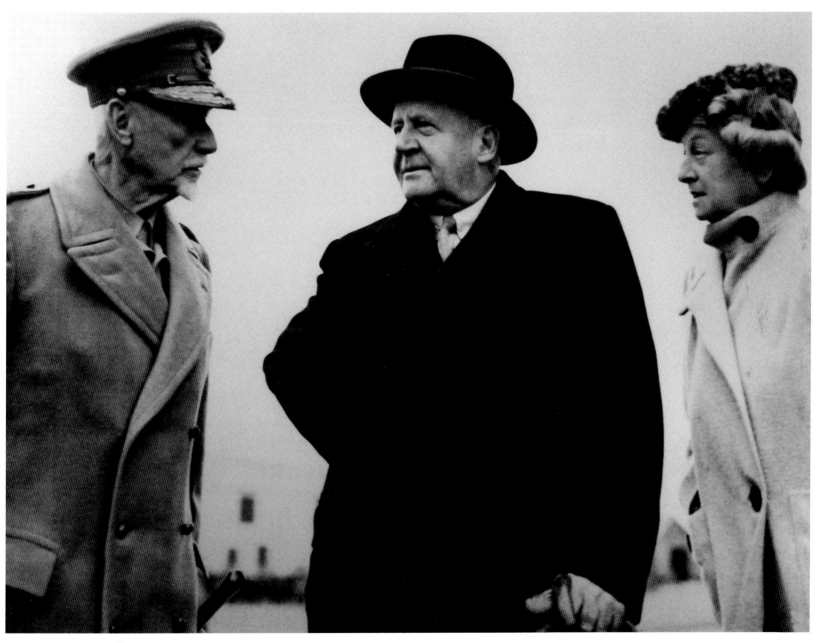

Smuts met up with his wartime comrade and friend Col. Deneys Reitz and his wife, Leila, while on his second visit to London in October 1943. Reitz served as the South African high commissioner there, but passed away a year later on 19 October 1944.

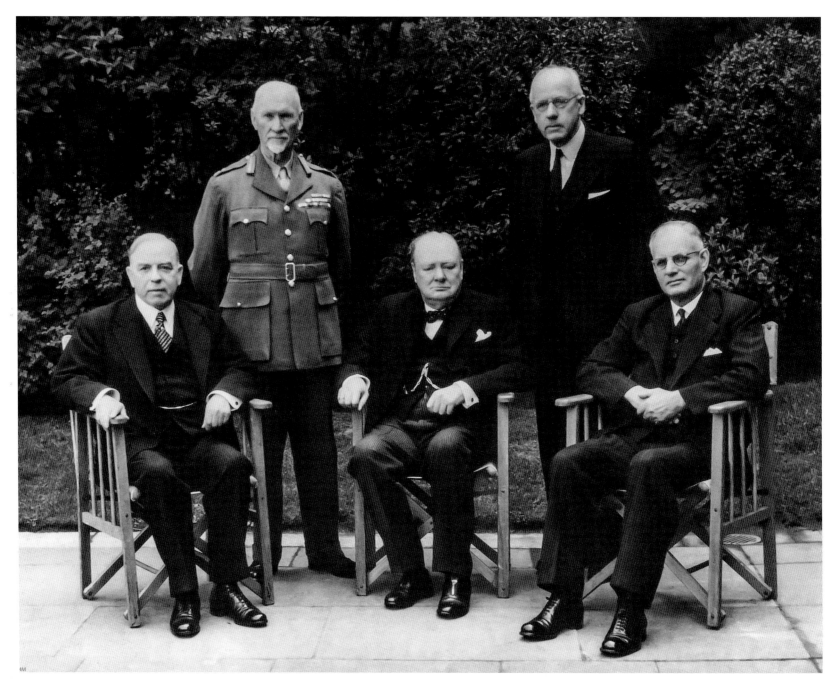

With the premiers of the British Commonwealth of Nations at the Commonwealth summit conference in London in May 1944. The planning of the Normandy campaign as well as the United Nations guidelines were discussed. This was Smuts's third wartime visit to London.

Giving the Churchill victory sign after attending the presentation of the freedom of the city to the dominion premiers of Australia and New Zealand at the Guildhall in May 1944.

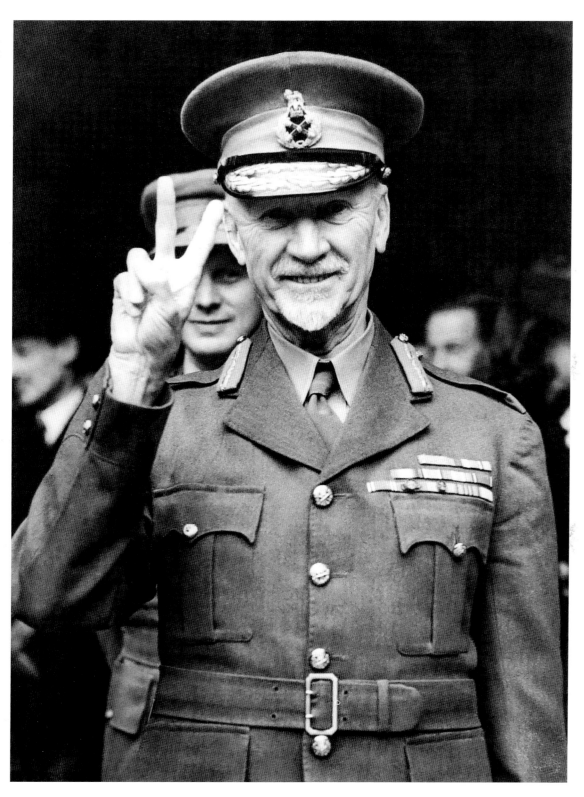

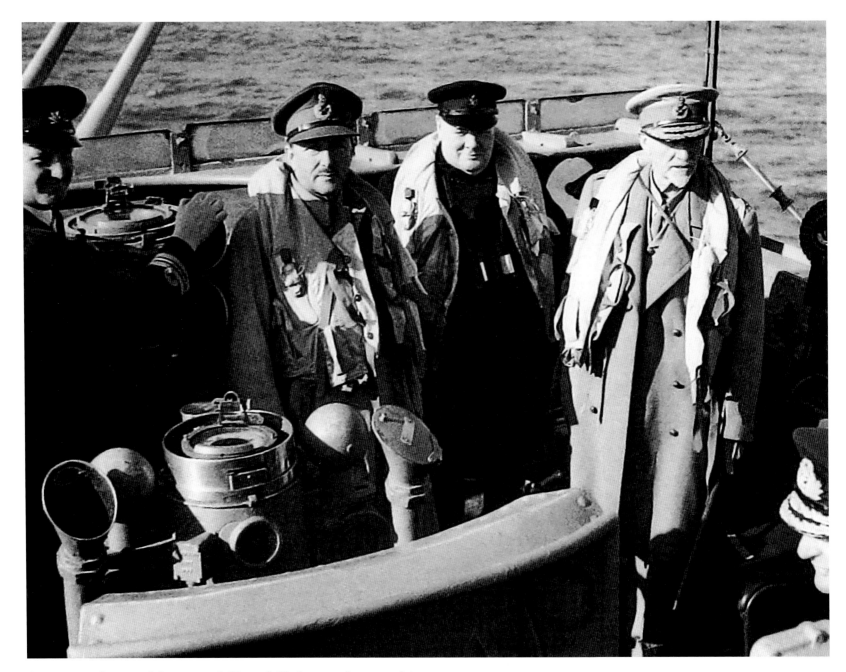

Smuts, as the special guest of Churchill, is seen here on his way to the beaches where the famous landings took place in Normandy. This visit on 12 June 1944 was only six days after the occupation. To Churchill's left is Field Marshal (Sir) Alan Brooke, head of Imperial Staff, and Churchill's right-hand man.

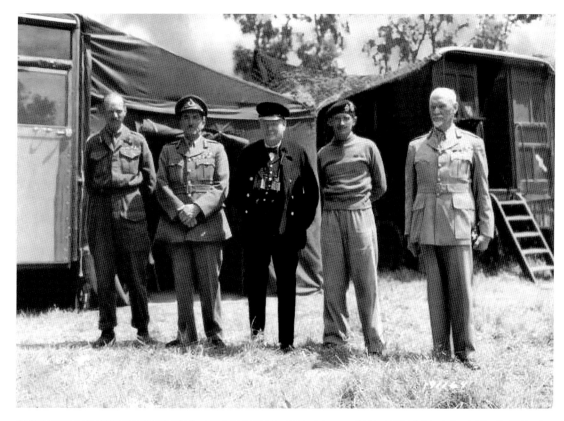

On the same day, Smuts and Churchill visited Montgomery, commander-in-chief of the 21st Army Group in Europe, at his headquarters. Second from the left is Field Marshal Brooke, with Gen. Montgomery second from the right. Note that Smuts holds his movie camera – he was not in the official photo that was taken of the Normandy visit, because he wanted to film the occasion himself.

Soon after Normandy, Smuts left for home, and on his way back visited the troops in North Italy on 25 June 1944. Here are Smuts and Maj. Gen. W.H. Evered Poole, the South African commander of the 6th SA Armoured Division in Northern Italy, shortly after Smuts's arrival in Italy.

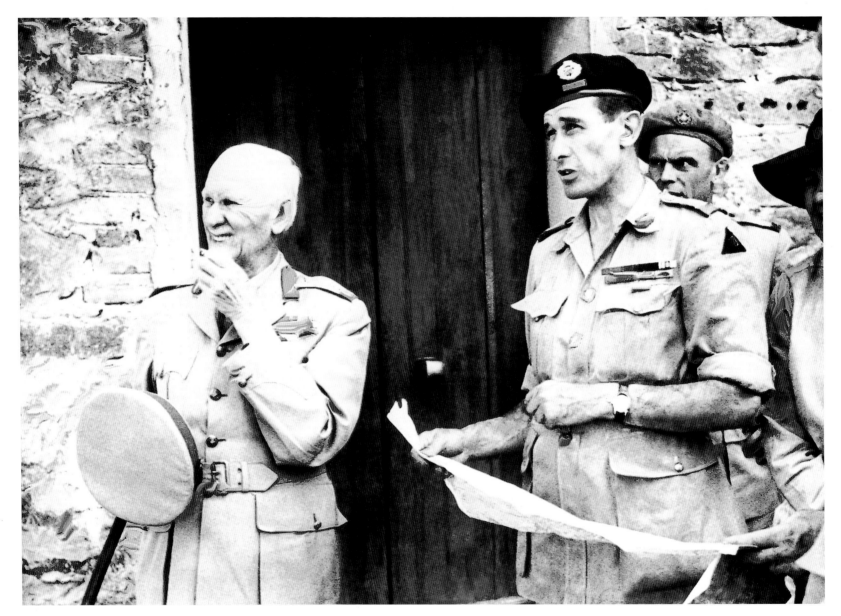

Poole shows Smuts the plan of attack to be followed by the
6th SA Armoured Division on Monte Sole, Italy.

OPPOSITE During a quick tour of the Armoured Division's
operational zone in Italy, Smuts paused for five minutes to
film the devastation at Orvieto railway station caused by
fierce ground fighting and SA Air Force bombing.

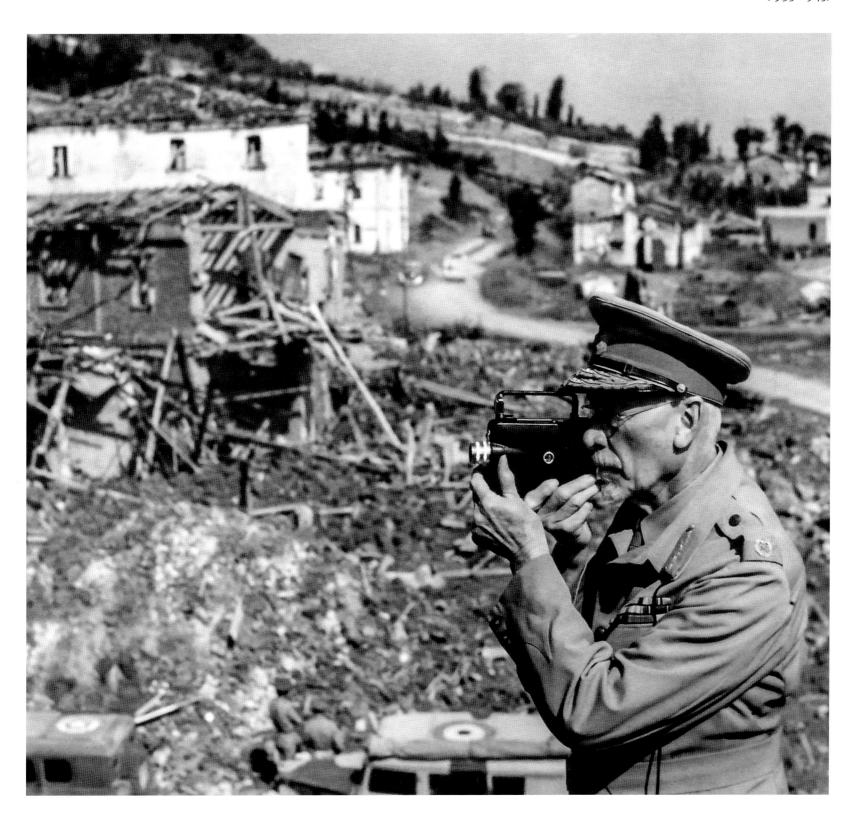

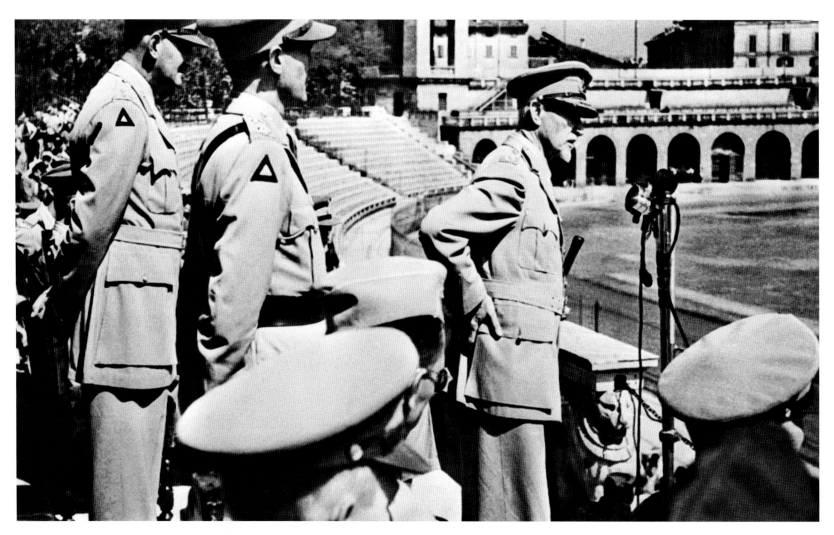

Smuts addresses the Armoured Division while on his visit to Orvieto in the last week of June 1944. Behind him are Maj. Gen. Poole and Brig. J.P.A. Furstenburg.

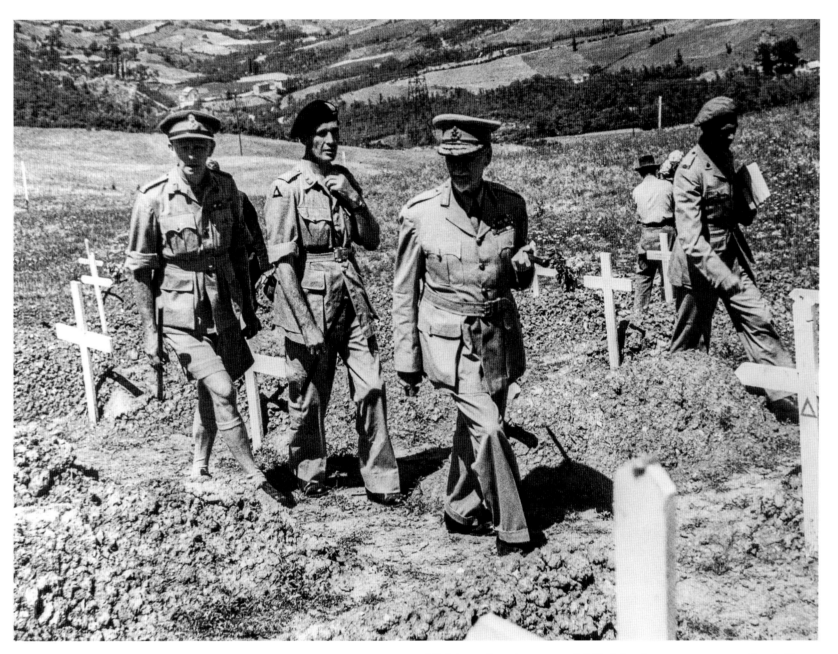

Visiting the Armoured Division's cemetery at Castiglione on 10 July. Walking with Smuts are Poole and Maj. Gen. F.H. Theron, general officer of administration in the Union Defence Force.

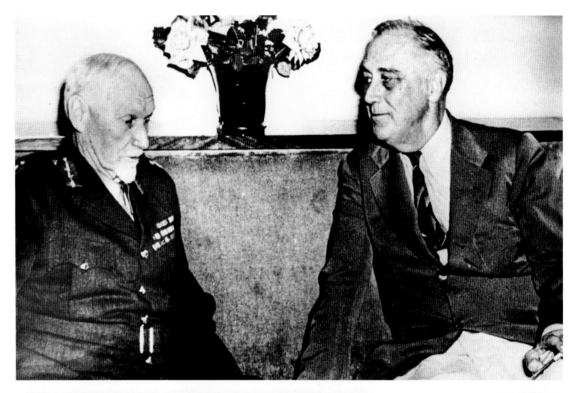

Smuts and President F.D.R. Roosevelt discuss the new priorities of the war and the envisioned United Nations during a stopover visit to Cairo in February 1945. Roosevelt died a few weeks later, on 12 April 1945, and was succeeded by Harry S. Truman.

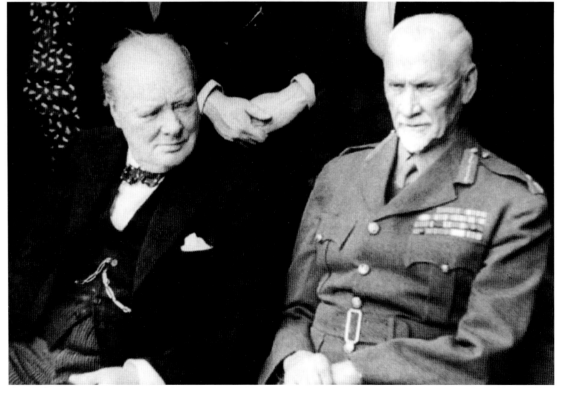

The 74-year-old Smuts and Churchill at the British Commonwealth of Nations meeting in London in April 1945, in preparation for the establishment of the United Nations Organisation in San Francisco. This was his fourth wartime visit and also the longest and most tiring, lasting almost four months. He visited England, Europe, Canada and the United States.

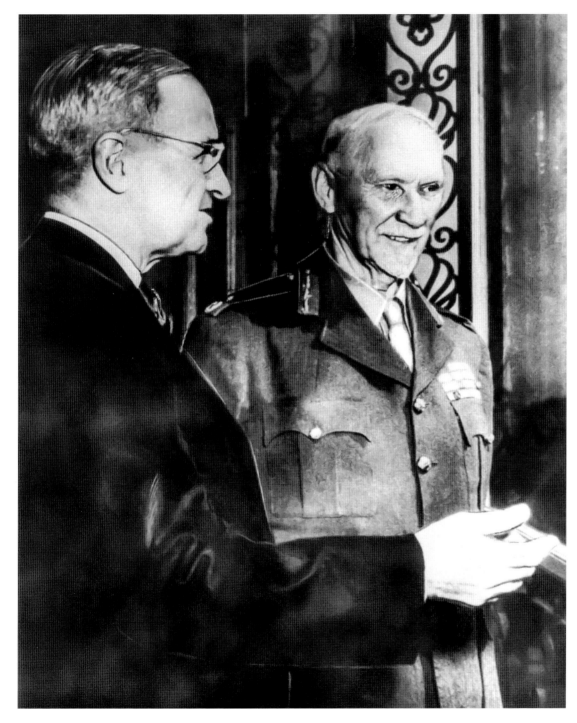

With the new president of the United States, Harry S. Truman, at the founding conference of the United Nations in San Francisco in May 1945.

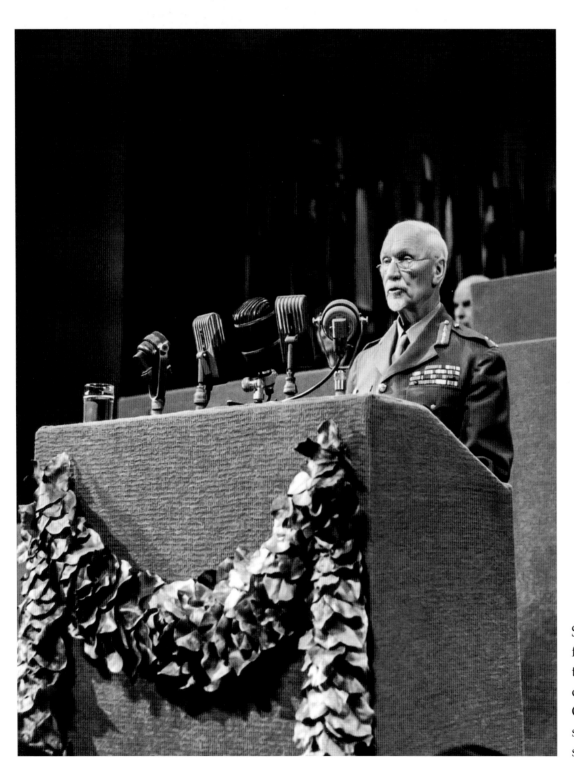

Smuts was largely responsible for formulating the Preamble to the United Nations Charter. Here he is addressing a general session of the UN Conference on international organisation, cooperation, supervision and security in June 1945.

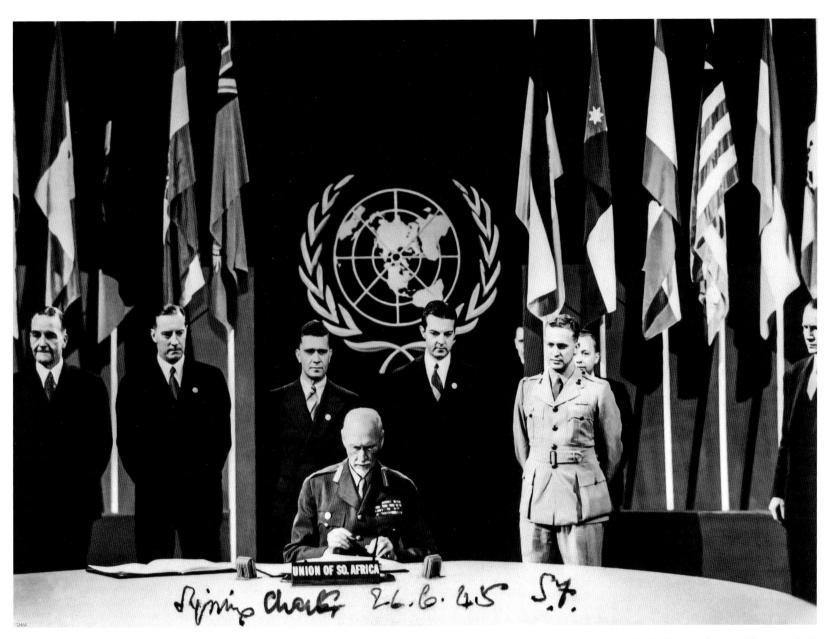

Signing the Charter on 26 June 1945. Smuts himself regarded this as the highlight of his political career.

Last lap
1945–1950

"This is a good world. We need not approve of all the items in it, nor of all the individuals in it; but the world itself — which is more than its parts or individuals; which has a soul, a spirit, a fundamental relation to each of us deeper than all other relations — is a friendly world."

IN MID-1945, SMUTS PAID HIS LONGEST wartime visit overseas – to Britain, Europe, Canada and the United States. In London he attended the Commonwealth prime ministers' conference, convened to discuss the proposed United Nations Charter.

Unhappy with the dry, legalistic wording of the Charter, Smuts proposed the inclusion in the Preamble of references to basic human rights and freedoms – of religion, tolerance, free speech, self-defence against invasion – unaware that his own country would become the prime victim of the institution he was helping to create. Described by Anthony Eden as "the doyen of the Conference – quite unrivalled in intellectual attributes and unsurpassed in experience and authority", Smuts presided over a commission of the General Assembly and was present at the opening of the United Nations Organisation by President Truman on 25 April 1945.

Only days later, on 7 May, Germany surrendered and at long last the war in Europe was over. In 1946, Smuts attended the peace conference in Paris which set out the terms on which the defeated Axis powers could resume their sovereignty and become members of the UN. On 10 February 1947, he co-signed the peace treaties and was the only statesman present who also was at Versailles in 1919 – almost 28 years earlier.

Back home, however, Smuts's political problems were multiplying. After eight years in office, there was widespread disenchantment with his government's performance, and racial animosities had resurfaced with a vengeance. Every effort that he made to lessen racial restrictions was seized upon by his Nationalist opponents as evidence that he was endangering white rule over the country.

At the UN, South Africa was denied permission to incorporate South West Africa into the Union and was harshly criticised by the Indian government for its segregationist policies, which evoked further fear and resentment among white voters.

In 1947, politics took a back seat as King George VI and his wife Elizabeth accepted Smuts's invitation to visit the Union for a lengthy tour – the monarch's first visit to a Commonwealth country.

Anticipating another victory at the polls in 1948, Smuts neglected to reinvigorate his elderly cabinet or to even out the disparity in voter numbers between urban and rural seats. He received a rude shock when D.F. Malan's NP narrowly won the election with a minority of votes but a majority of seats. Smuts warned that the NP's apartheid policies were no solution to South Africa's racial problems and would prove disastrous internationally in the years ahead.

Besides heralding the end of the 78-year-old Smuts's domination of South Africa's politics, 1948 proved to be a year of disappointment and sadness for him. In October, his beloved eldest son, Japie, died suddenly from cerebral meningitis, followed shortly afterwards by the deaths of his wartime colleague and friend Hendrik van der Bijl and – one day later – his protégé and trusted deputy, Jan Hofmeyr, who succumbed to heart failure from overexertion at the age of only 54. A grieving Smuts's only consolation in a grim year was his unanimous election as the chancellor of Cambridge University, an honour he prized as much as any other.

Smuts's family tried to persuade him to retire from politics, but fearing the UP might split after Hofmeyr's death, he decided it was his duty to soldier on for longer despite his failing health. In May 1950, he attended ceremonies in Johannesburg and Pretoria to mark his 80th birthday, but after a series of heart attacks, he was not seen in public again. He died suddenly after supper at the family home at Doornkloof, Irene, on 11 September 1950.

Until the age of 80, Smuts had been directly involved in most major historical crossroads in South Africa and abroad. It was a period in which some of the greatest changes in world history took place. His strong influence in tipping points where the Union of South Africa would reach maturity and where many Western monarchies that were in conflict had to make room for new democracies cannot

be denied. New world orders with formal, internationally acclaimed organisations, such as the United Nations, were established and still function today. Smuts, despite his faults and shortcomings, was an influential, visionary leader, co-founder of two world organisations of the twentieth century and an important role player as South African and international world leader of his time. ✍

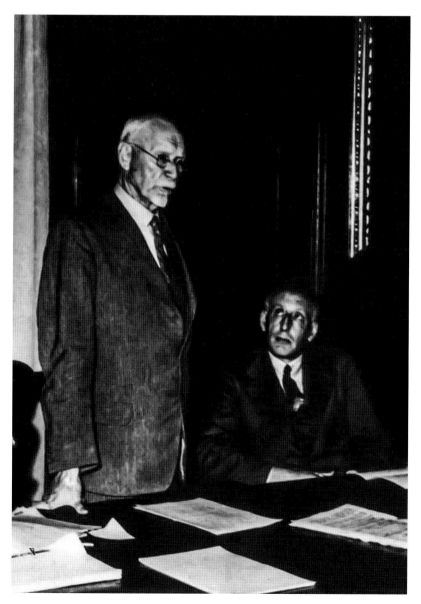

With his vision on technology, his involvement in the British war cabinet, his wide knowledge of missile technology, as well as his dealings at the conference of the UN, Smuts realised that South Africa needed to establish a council for scientific and industrial research. Because of his influence and efforts, the CSIR was duly founded. Here he is shown addressing the first formal meeting of the council on 8 October 1945. Dr Basil Schonland, the first president of the CSIR, is sitting next to him.

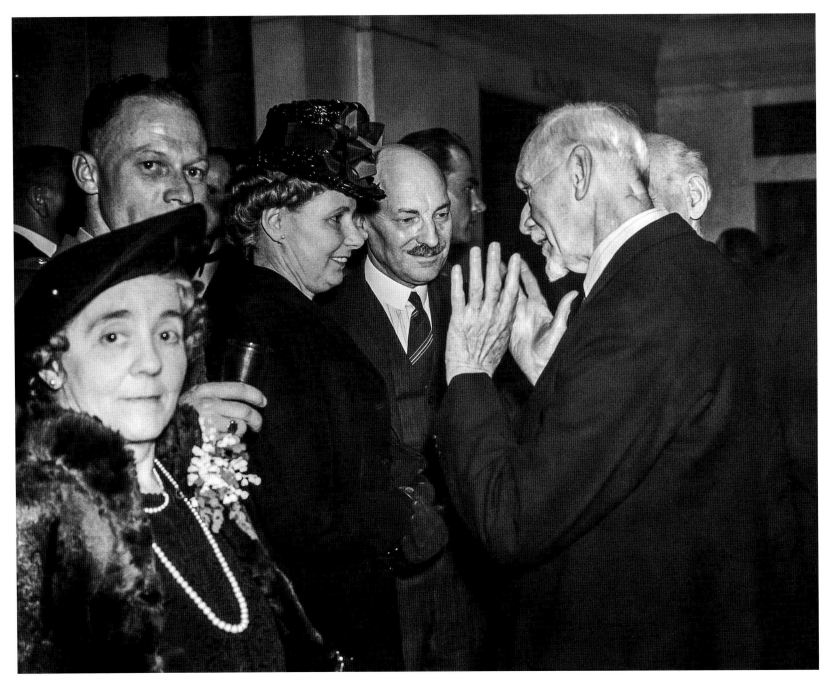

At a function in 1946 in South Africa House in London, B. Booysen, at the back, left, with a glass in his hand, overheard an elated Smuts tell the new British prime minister, Clement Attlee, and his wife: "We won the war, now we must win the peace!"

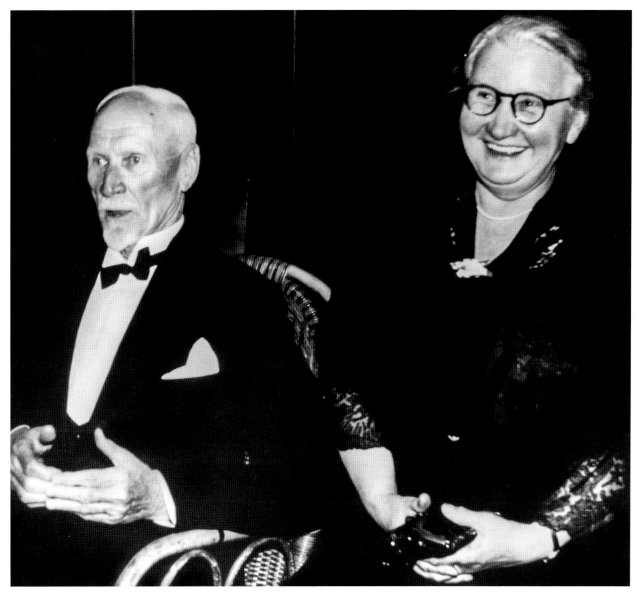

In high spirits with his sister Adriana Martha (6 July 1884 – 21 January 1952) at an event in 1947. "Aunt Bebas" was a teacher and later principal of the Industrial School for Girls in Paarl. After retirement, she moved to Hermanus. She was mayor from 1938–1941, and co-founder of the new expanded town in 1941. She was re-elected as mayor (1941–1948) after three smaller areas consolidated with the then Hermanus boundaries. She never married, and Smuts often went to visit her in Hermanus.

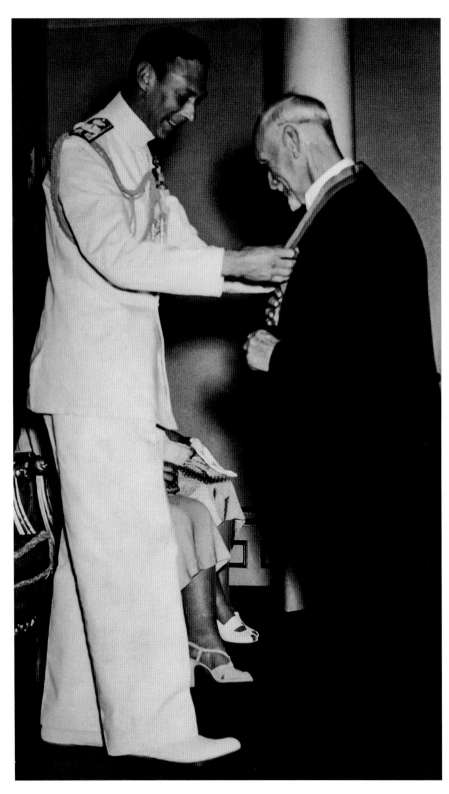

One of the surprises of the royal visit to South Africa in February 1947 was when King George VI on the very day of his arrival and without any announcement in advance, awarded Smuts with the Order of Merit, a British award never held simultaneously by more than 24 people. The award was presented at Tuynhuys, the official residence of the South African head of state.

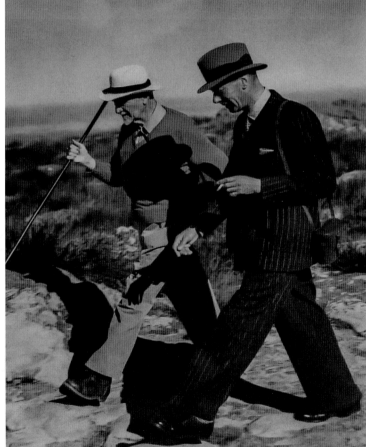

King George VI walking with Smuts on Table Mountain towards Platteklip Gorge. Smuts was delighted to show the monarch the magnificent view from the top.

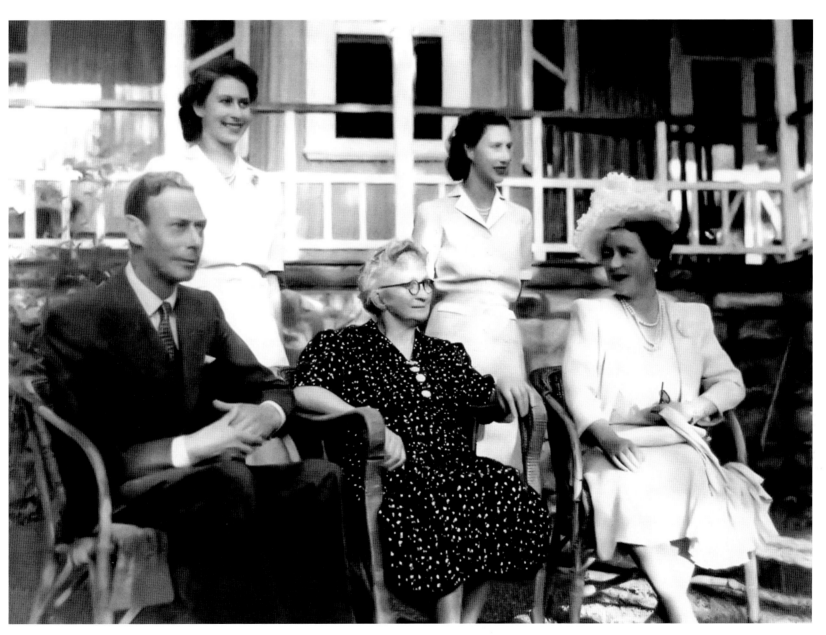

The Royal family visited Doornkloof in March 1947. Isie received them with her charming informality, "chatting to the King and Queen as though she had known them all her life".

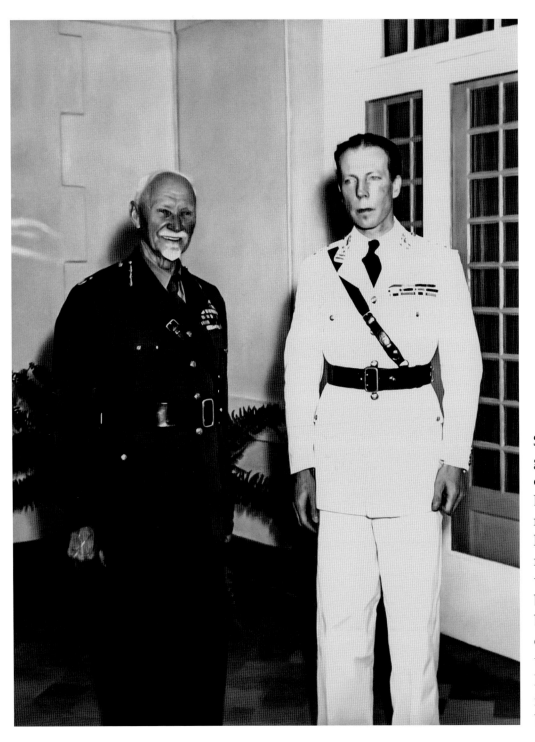

Smuts visited Prince-Regent Albert of Belgium in Elizabethville (now Lubumbashi), capital of the Katanga Province of the Belgian Congo in August 1947. The uranium for the atomic bombs of Project Manhattan in World War II was from a mine nearby. It is speculated that Smuts (who via Churchill was aware of the secret atom bomb development project) negotiated on behalf of Roosevelt with the prince for the exclusive use of the uranium. Smuts advised Truman (after Roosevelt's death in February 1945) on the ethics and far-reaching impact of the possible use of the atom bomb.

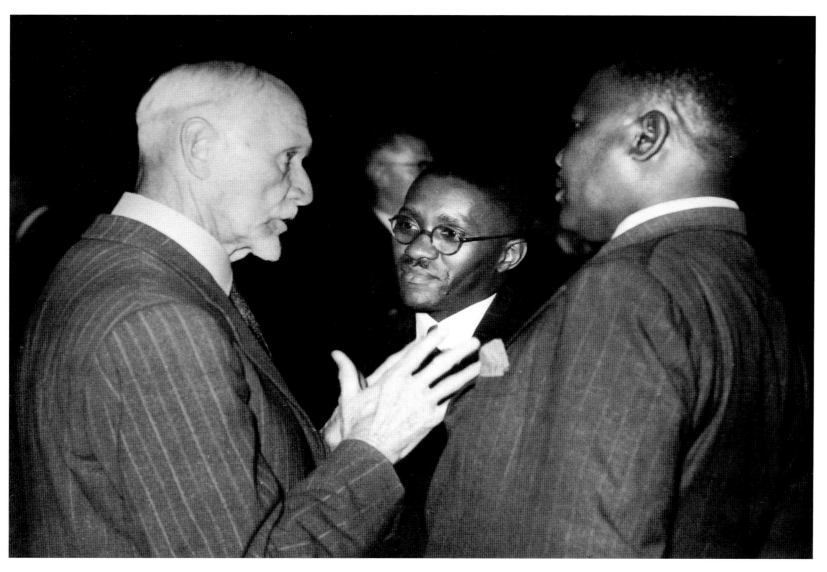

Having a serious discussion with the ANC leader Albert Luthuli in Pietermaritzburg in 1947. In the middle is A. Mtiukulu, head of the Adams Mission College. Luthuli was an alumnus of the college and a teacher there. He was elected president of the ANC in December 1952. In 1960, he won the Nobel Peace Prize.

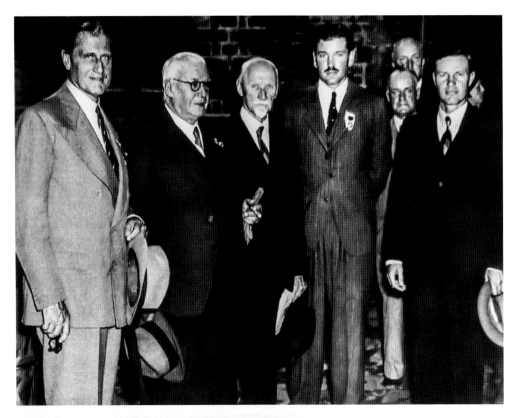

As president of the Western Province Agricultural Society, Sir De Villiers Graaff (centre) attends the opening of the Cape Town Show in March 1948. With him are Maj. Piet van der Byl (minister of native affairs), Maj. G. Brand van Zyl, (governor general), Smuts and J.G.N. Strauss (minister of agriculture). Strauss, earmarked as successor to Smuts, was removed in 1956 as leader of the opposition and "Sir Div" took over from him.

A pondering and disappointed Smuts at Doornkloof on 28 May 1948 after losing the election by a minority of seats, but with a majority of votes. He first called King George VI with the news before the official announcement was made nationally.

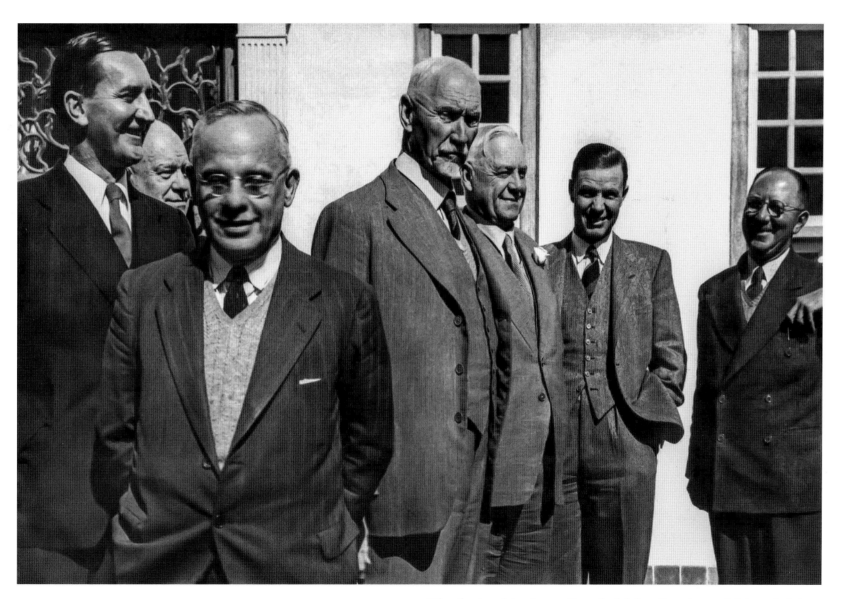

The last cabinet meeting held by Smuts and his ministers on 31 May 1948 at Libertas after the United Party defeat. From left to right are: Harry Lawrence, J.W. Mushet, J.H. Hofmeyr, Smuts, C.F. Clarkson, J.G.N. Strauss, and Dr Henry Gluckman.

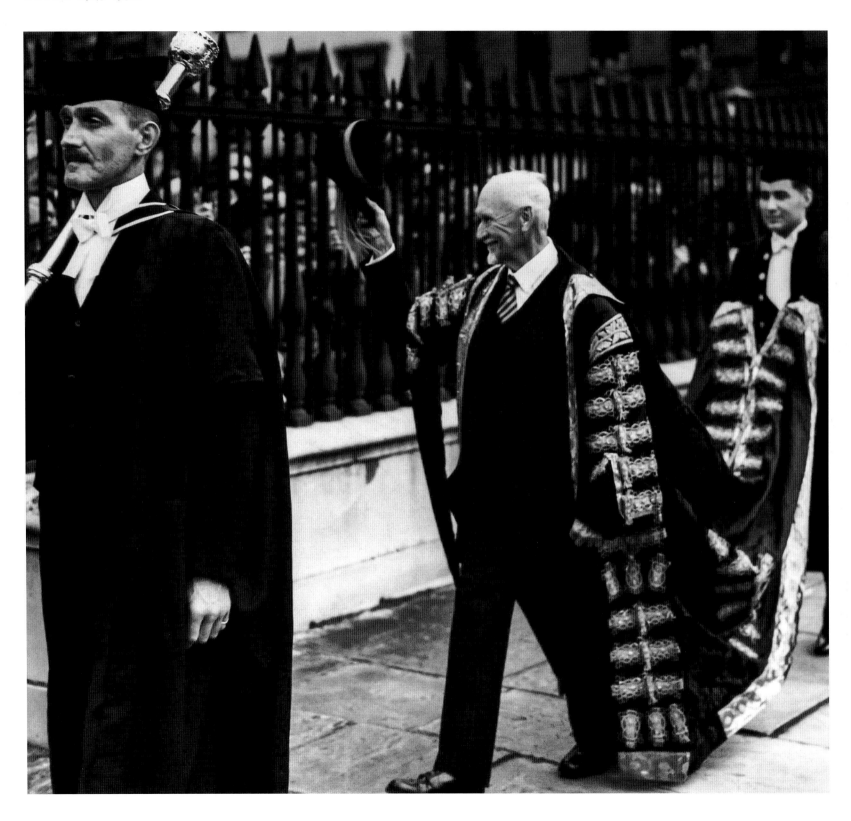

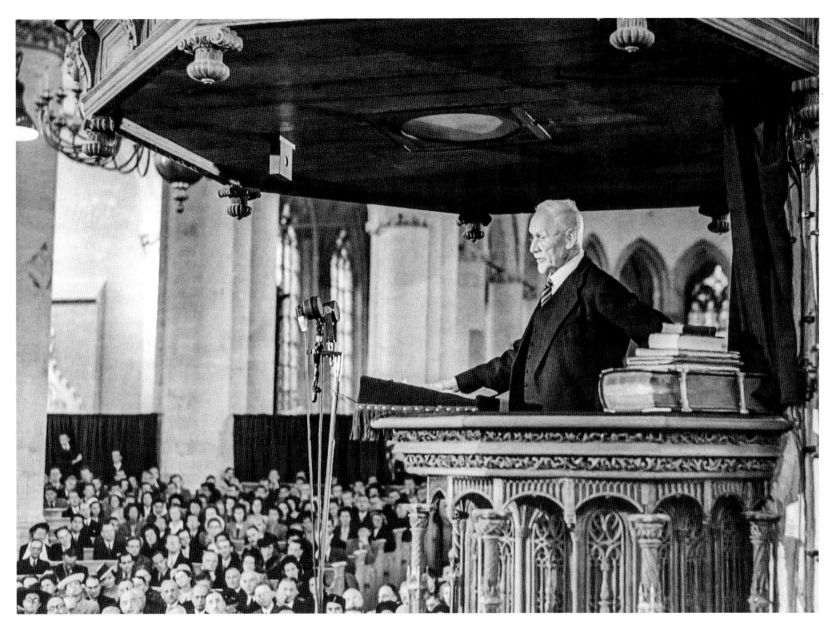

OPPOSITE Smuts was inaugurated as chancellor of Cambridge University on 12 June 1948. He was the first non-British citizen appointed to this position and to him it was indeed a great honour bestowed upon him by his alma mater. In his inaugural address he referred to a former British premier, Henry Campbell-Bannerman's wisdom half a century earlier that paved the way for the granting of self-government status to the former British colonies in South Africa.

ABOVE Here Smuts addresses the audience from the pulpit after receiving an honorary doctorate in Law from the University of Leiden in the Netherlands on 17 June 1948.

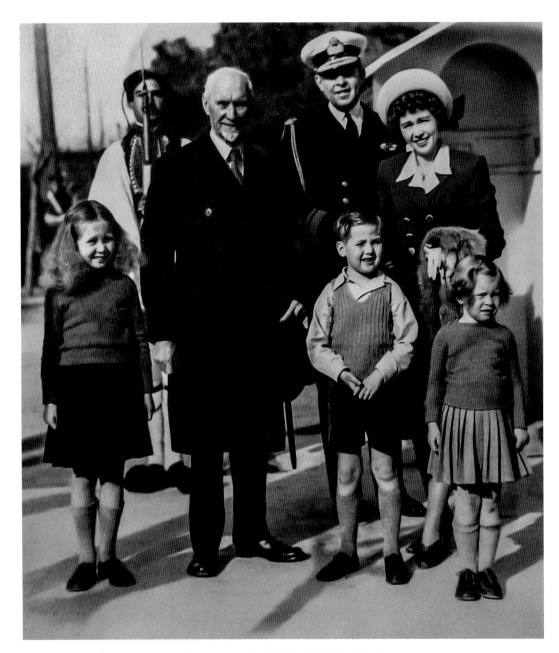

For their safety during the turmoil of World War II, Smuts invited the Greek royal family to take refuge in South Africa. Queen Frederika admired Smuts's extraordinary intellect and believed in the philosophy of holism that he promoted. Here he is photographed in June 1948 while visiting the family in Greece on his way back home after one of his trips to Britain and the Netherlands.

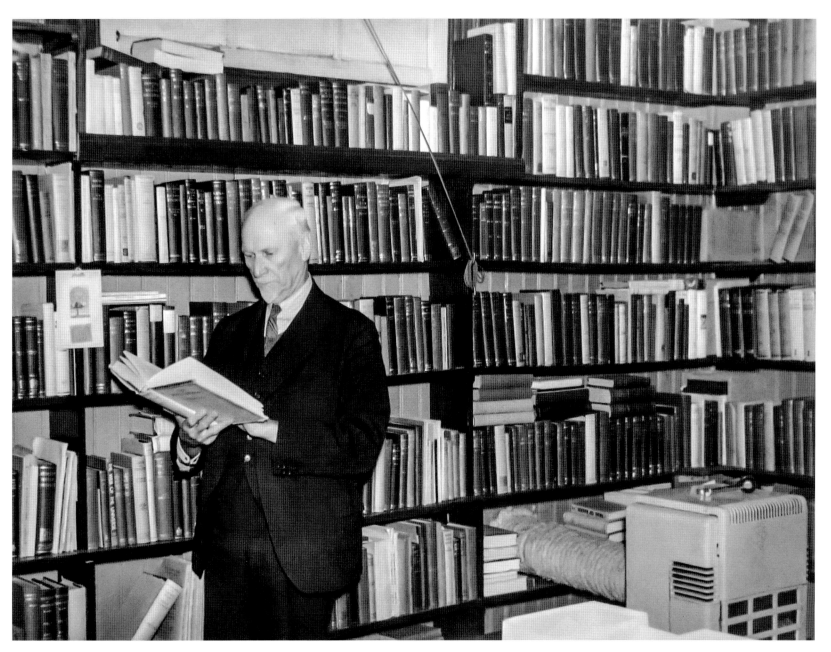

Smuts was an avid reader and book collector and owned some 6000 books. Here he is paging through a book in his library at Doornkloof. In the final days of his life, he read Emily Brontë's poems aloud to his nurse. Brontë was his favourite author and he considered her *Wuthering Heights* as great as anything Shakespeare had ever written.

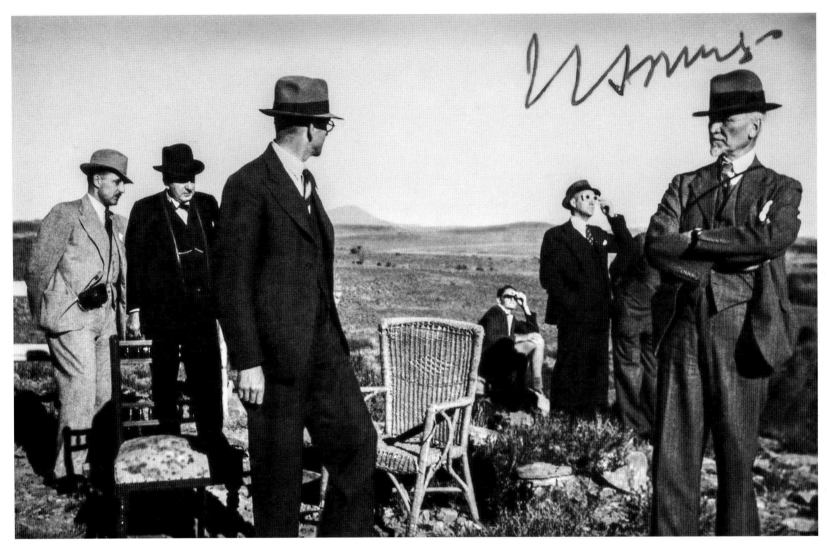

On a field expedition to watch the partial eclipse of the sun in
October 1949. Note the formal dress of Smuts and his friends.

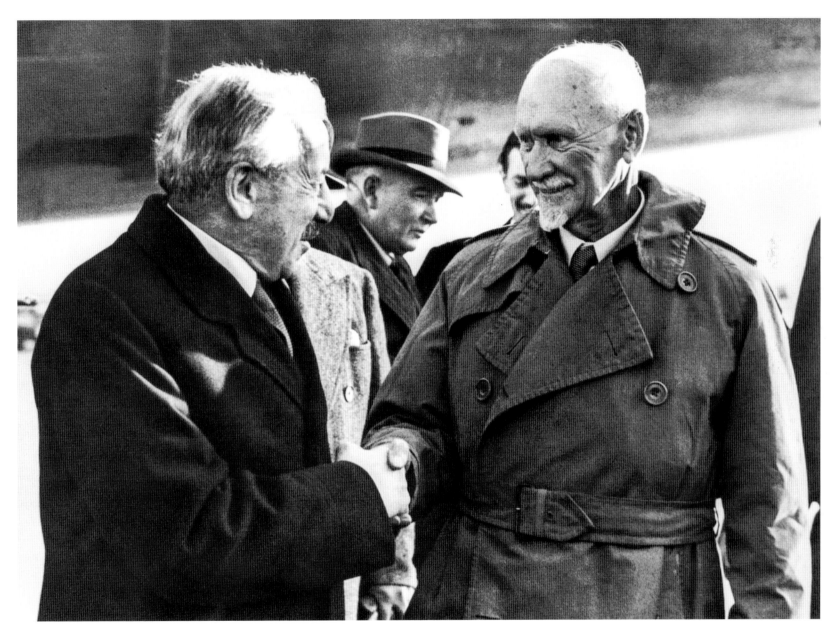

Smuts and the first president of Israel, Chaim Weizmann, who celebrated his 75th birthday in London on 27 November 1949. At the luncheon Smuts toasted his friend of three decades and gave a moving speech on the future of the new state of Israel. Weizmann was the driving force behind the World Zionist Organisation that resulted in the British government's Balfour declaration in 1917, in which it undertook to establish a "national home for the Jewish people in Palestine". With Smuts as supporter, especially with the founding of the UN in 1945, and South Africa as one of the first countries to acknowledge Israel in 1949, this explains the strong tripartite relationship between Britain, Israel and South Africa in the second half of the 20th century.

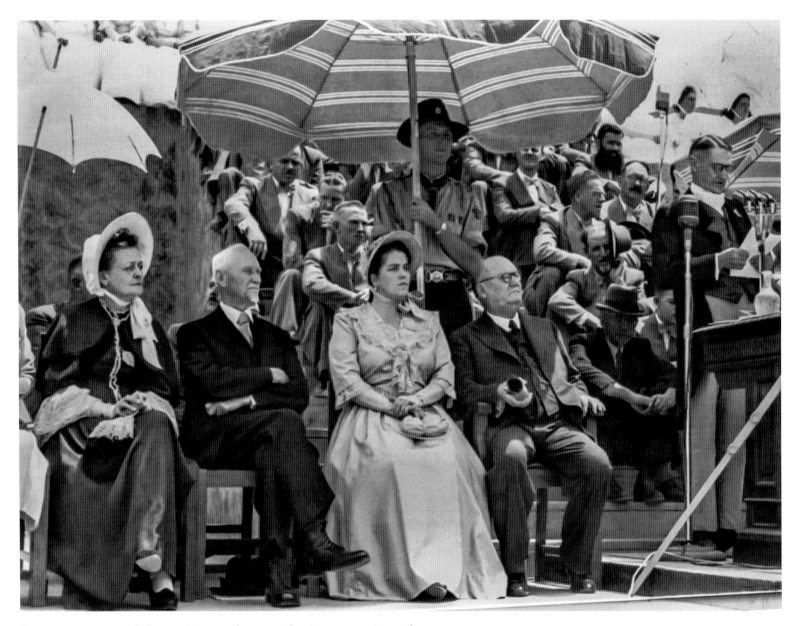

Smuts was one of the main speakers at the inauguration of the Voortrekker Monument outside Pretoria on 16 December 1949. To his left are Maria and D.F. Malan, who succeeded him as prime minister. Smuts and the Malans were good friends despite their political differences.

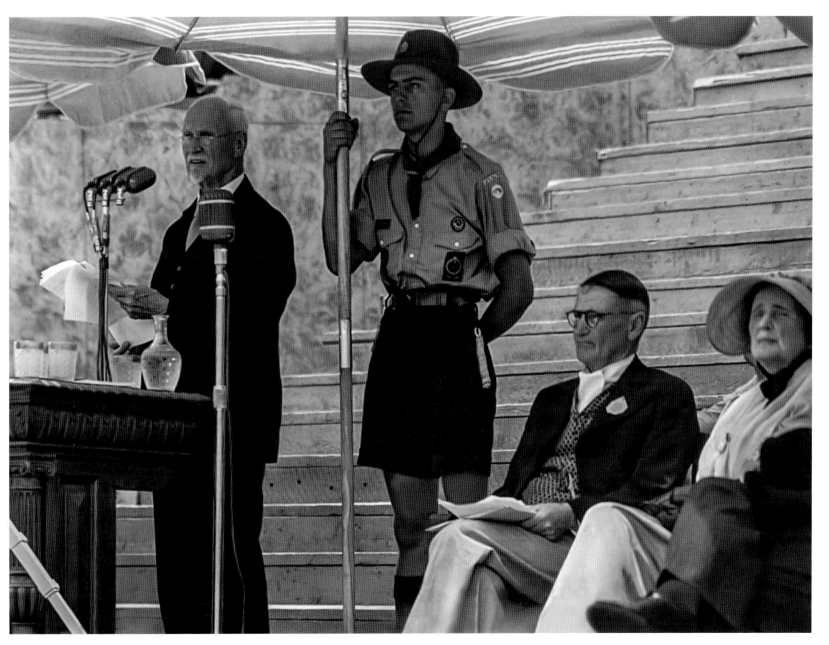

As the last surviving general of the Peace of Vereeniging, Smuts gave a heartfelt speech with the call: "Make peace with everyone from the past for the sake of the future." Sitting on the right is Advocate E.G. Jansen, the minister of native affairs, and his wife, Mabel. Jansen was a member of the United Party until 1939, but joined Hertzog when he split.

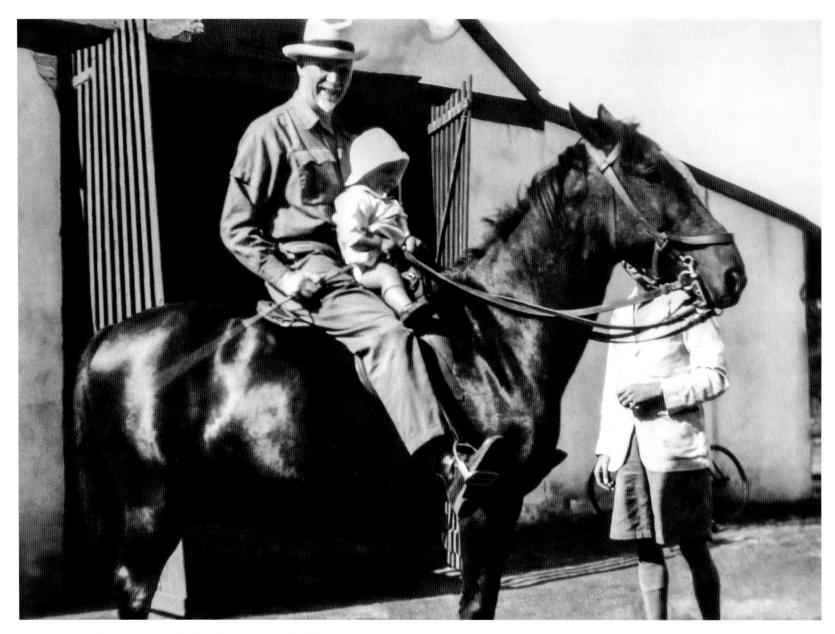

Sitting astride Ruiter with his first grandchild, Jan Weyers.

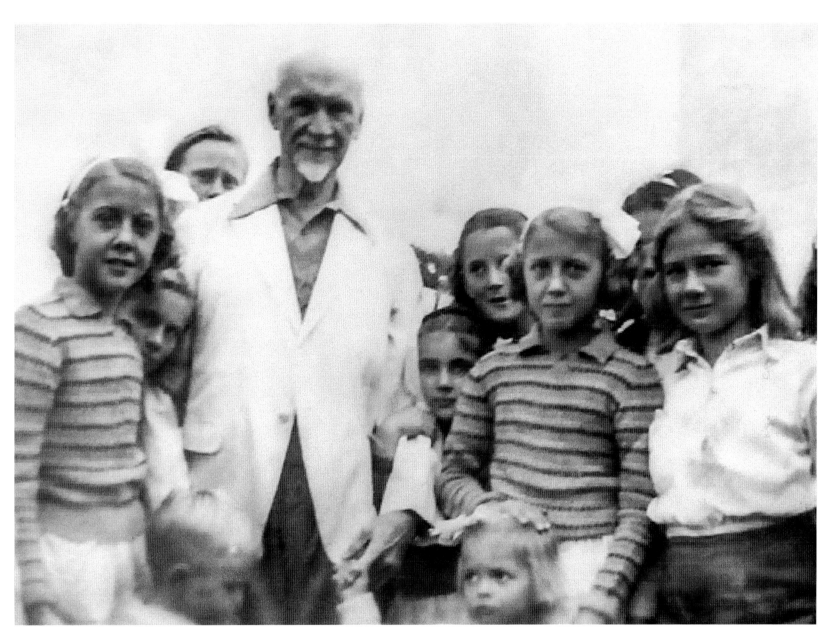

Smuts adored children. Here he was photographed in 1948 relaxing with the Sunday school children of the St Andrews Presbyterian Church at the annual Ascension Day picnic they enjoyed on his farm. He often visited St Andrews when he was at Doornkloof. The twins with him, dressed alike, are Annette and Jeanette Bentley.

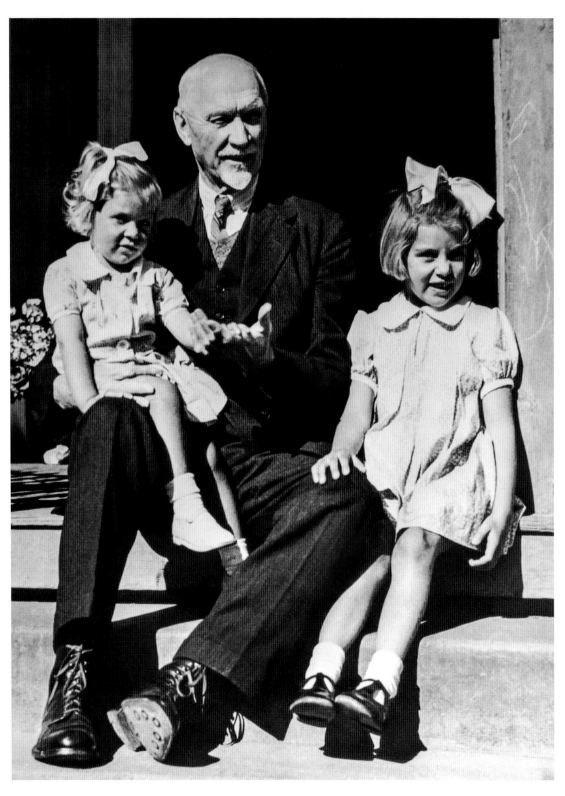

Smuts with two of his grandchildren, Lilian (on his knee) and Sybilla, in front of the homestead at Doornkloof.

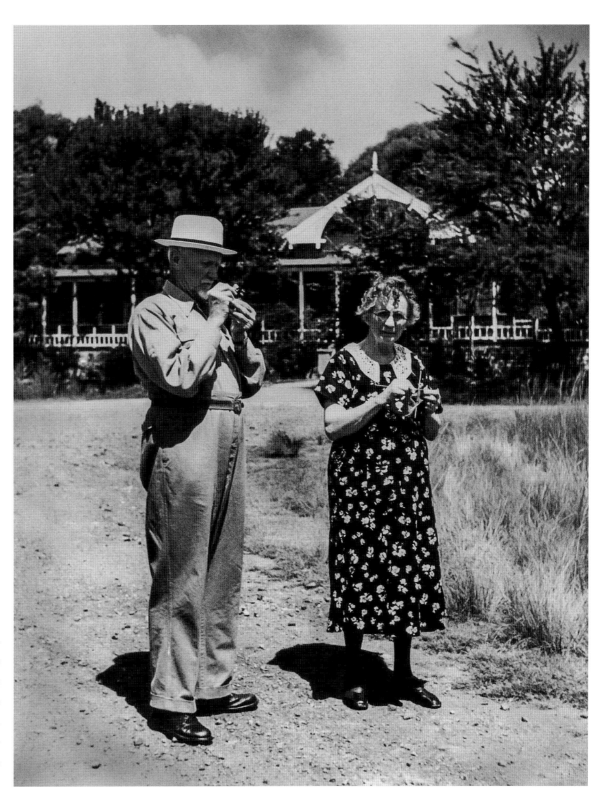

As an avid botanist, Smuts wanted to experience nature and see the field plants from his Irene stoep. Strolling with his magnifying glass next to Isie, who is busy with her knitting, he studies the various grass plants growing in front of the house.

After opening a fête at the Marsh Memorial Home for orphans in 1950 and signing one of the children's autograph books, he pondered for a few seconds, holding his pen. This photograph was taken just before his 80th birthday and is probably the last one of Smuts in Cape Town.

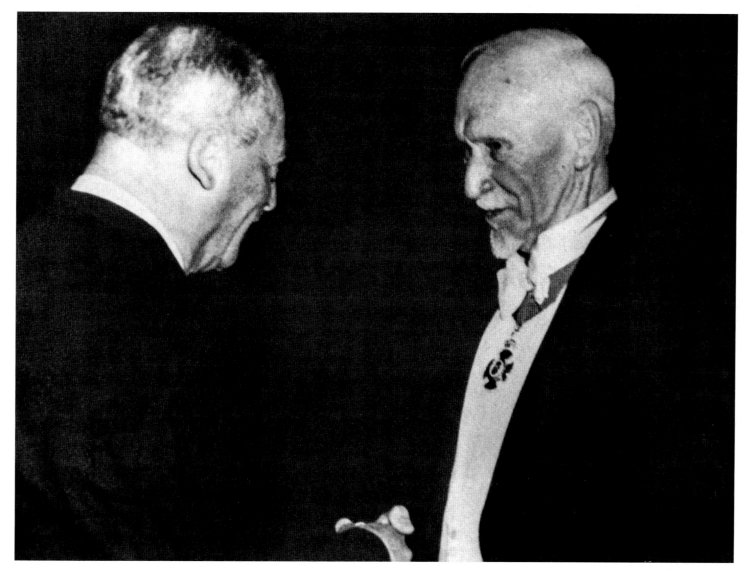

Sir Ernest Oppenheimer congratulates his old friend General Smuts on his 80th birthday on 24 May 1950 in Johannesburg. On this occasion he was granted the freedom of Johannesburg. Some 300 000 people filled the streets to celebrate the occasion.

With his two-year-old grand-daughter Mary (daughter of son Jannie) at Doornkloof on 10 September 1950, the day before he died. This is the last photograph taken of him.

A draped black charger, bearing Smuts's riding boots and spurs hanging back-to-front from the saddle, took part in his military funeral cortège in Pretoria on 15 September 1950. This custom is a special mark of respect reserved for a field marshal.

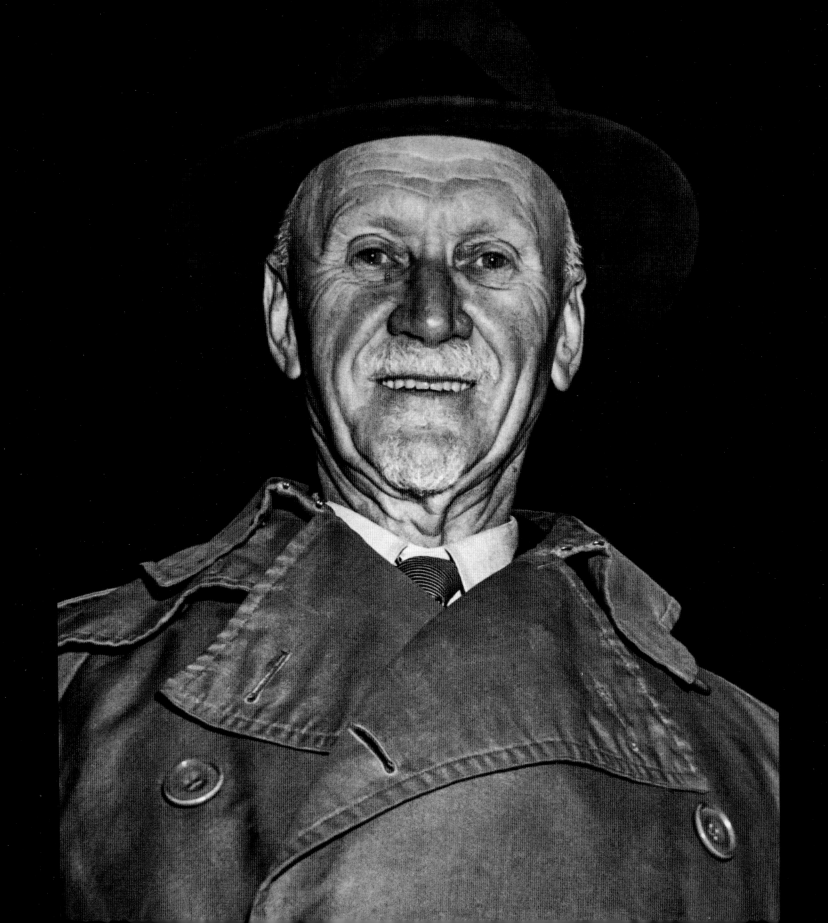

"Jan Smuts did not belong to any single state or nation. He fought
for his own country, he thought for the whole world."
WINSTON CHURCHILL

"He could hold an audience in the hollow of his hand, partly because
he was Smuts, partly because he could say nothing trite or shallow,
partly because he knew how to speak to ordinary men and women."
ALAN PATON

"I wish you could meet him, he is so cultivated and clever and full of fun,
though underneath of course he is broken-hearted at the loss of his country."
EMILY HOBHOUSE

"In peace or in war, his courage and his friendship
were of extreme value … while the force of his intellect has
enriched the wisdom of the whole human race."
KING GEORGE VI

Acknowledgements

MANY PEOPLE CONTRIBUTED TO THIS PUBLICATION. Nicol Stassen showed interest in and encouraged the project throughout. Ideas about the book were discussed with Kobus du Pisani on occasion, and extremely valuable tips, documents and information were obtained from cultural historian Annemarié Carelsen.

To the staff of various archives countrywide who assisted me with the collection of rare images, of which the SANDF Archives was the most important source, I give full credit. Also to Lila Komnick of the Parliament's archives, Marise Bronkhorst, archivist at the Western Cape Archives and Records Service, and to Philip Weyers, who kindly granted me access to the photo collection of the Smuts House Museum. Also to Richard Steyn for his inputs.

A special word of gratitude to Fransjohan Pretorius for writing the foreword to this book. My thanks also to the Protea team that made this book a reality – Danél Hanekom as editor, Carmen Hansen-Kruger as proofreader and Hanli Deysel for her layout and cover design. Also to Frans Pietersen for his expertise and help retouching some of the photographs.

This publication is dedicated to my friend Charles Comley, who started this journey with me but died unexpectedly in January 2021. Finally, my wife Amalie supported me from start to finish and her critical eye and opinion on the retouching of images were invaluable.

This photobiography was compiled from collections of photographs held at:

Smuts House Museum (SHM)
Archives of the SA Parliament
SANDF Archives
Western Cape Archives and Records Service
Anton Joubert Collection

Further acknowledgement for some individual photographs:

University of Stellenbosch Archives:
Smuts's honorary doctoral degree, 1931
University of the Orange Free State Archives:
Roosevelt and Truman with Smuts
CSIR Archives: Foundation meeting
Unisa: Orvieto

Main sources consulted

Cameron, T. 1994. *Jan Smuts: An illustrated biography.* Cape Town: Human & Rousseau.

Crafford, F.S. 1947. *Jan Smuts: 'n Biografie.* Translated by F.A. Venter. Cape Town: Edina Works.

Du Pisani, K., Kriek, D. & De Jager, C. 2017. *Jan Smuts: Son of the veld, pilgrim of the world.* Pretoria: Protea Boekhuis.

Friedman, B. 1975. *Smuts: A reappraisal.* Johannesburg: Hugh Keartland Publishers.

Hancock, W.K. 1962. *Smuts, volume 1: The sanguine years, 1870–1919.* Cambridge: Cambridge University Press.

Hancock, W.K. 1968. *Smuts, volume 2: The fields of force, 1919–1950.* Cambridge: Cambridge University Press.

Joseph, J. 1970. *South African statesman Jan Christiaan Smuts.* Folkestone: Bailey Bros. & Swinfen Ltd.

Levi, N. 1917. *Jan Smuts, being a character sketch of Gen. the Hon. J.C. Smuts, K.C. M.L.A., Minister of Defence, Union of South Africa.* London: Longmans, Green and Co.

Macdonald, T. 1948. *Jan Hofmeyr, heir to Smuts.* London: Hurst & Blackett, Ltd.

Millin, S.G. 1936. *General Smuts.* London: Faber & Faber.

Millin, S.G. 1936. *General Smuts: The second volume.* London: Faber & Faber.

Meiring, P. 1974. *Jan Smuts die Afrikaner.* Cape Town: Tafelberg.

Reitz, D. 2013. *Commando. Of horses and men.* Cape Town: Cederberg Publishers.

Smuts, J.C. (Jnr). 1952. *Jan Christian Smuts.* Cape Town: Heinemann.

*Magazines and newspapers (from a collection
of the Smuts House Museum Archives)*

"A Record of the Organisation of the Director-General of War Supplies 1939–1945", Dr H.J. van der Bijl, foreword by Gen. Smuts.

Die Suiderstem, 27 April 1940. "Van Boerseun tot die Statebond se Vooraanstaande Staatsman", supplement.

Libertas, July 1945. "WELCOME" General Smuts at reception on 21 July Union Buildings, photo report.

LIFE, 8 Nov. 1943. "Jan Christiaan Smuts, The Prime Minister … with unique prestige and power" by Noel F. Busch.

Picture Post: Hulton's National Weekly, Dec. 1940. "General Smuts: A Great Empire Leader".

"South Africa at War", 1943, compiled by SA Public Relations and Information Office.

South Africa Weekly Journal, 4 June 1910. "The Union of South Africa an Accomplished Fact".

South Africa Weekly Journal, special supplement, 7 July 1945. "Salute To The Oubaas".

The African World, "General Smuts in England in 1934" published in November 1934, special publication.

The Contemporary Review Advertiser, April 1944. "Botha and Smuts: Par Nobile Fratrum" by Prof. Basil Williams.

The Nongqai, Jan. 1917. "With General Smuts in the Field", snapshots in "The Great Advance in East Africa".

The Nongqai, March 1917. "General Smuts' Return", photo report in Pretoria.

The Nongqai, Sep. 1916. "With Smuts in The East", photo report on East Africa.

The Springbok, May 1950. "Jan Smuts", various articles on his 80th birthday.

The Springbok, October 1950. "Totsiens Oubaas".

Times History of the War, WWI, "German East African Campaign", Vol. 10, Chapter CLV.

"Vanguard of Victory", A Short Review of the South African Victories in East Africa 1940–1941 by Conrad Norton and Uys Krige, Correspondents of Bureau of Information.

"VREDE Oorsig", 1945. Special publication.

Index